HOW THE FOREIGN EXCHANGE MARKET WORKS

OWENS COMMUNITY COLLEGE P.O. Box 10,000 Toledo, Ohio 43699

Rudi Weisweiller

Library of Congress Cataloging-in-Publication Data

Weisweiller, Rudi.

How the foreign exchange market works / Rudi Weisweiller. -Original English language ed.

Includes bibliographical references and index.

ISBN 0-13-400862-6

1. Foreign exchange. 2. Foreign exchange futures. I. Title 1990

HG3821.W45

332.4'5-dc20

90-39200 CIP

Original English language edition published in the United Kingdom under the title Introduction to Foreign Exchange (2nd Edition)

© 1984, 1990 by Rudi Weisweiller

Published in the United States and Canada by NYIF Corp. A Division of Simon & Schuster Inc., 2 Broadway, New York, New York 10004.

Woodhead-Faulkner (Publishers) Limited, Simon & Schuster International Group, Fitzwilliam House, 32 Trumpington Street, Cambridge CB2 1QY, England.

All rights reserved. No part of this book may be reproduced in any form or by any means, without permission in writing from the publisher.

10 9

This publication is designed to provide accurate and authoritative information in regard to the subject matter covered. It is sold with the understanding that the publisher is not engaged in rendering legal, accounting, or other professional service. If legal advice or other expert assistance is required, the services of a competent professional person should be sought.

—From the Declaration of Principles jointly adopted by a Committee of the American

Bar Association and a Committee of Publishers and Associations

1-2-14004-5-P

ATTENTION: CORPORATIONS AND SCHOOLS

NYIF books are available at quantity discounts with bulk purchase for educational, business, or sales promotional use. For information, please write to: Prentice Hall Career & Personal Development Special Sales, 240 Frisch Court, Paramus, NJ 07652. Please supply: title of book, ISBN number, quantity, how the book will be used, date needed.

NEW YORK INSTITUTE OF FINANCE Paramus, NJ 07652

On the World Wide Web at http://www.phdirect.com

Contents

ABOUT THE AUTHOR, XIII PREFACE, XV

CHAPTER 1
Why Foreign Exchange?, 1

Basic Principles, 2
Price, 3
The Reason for Foreign Exchange, 5
Whom This Market Serves, 5

CHAPTER 2
How the Market Works, 9

Foreign Exchange Dealing Systems, 9 Foreign Exchange Brokers, 10 Deposit Brokers, 13

Contents

The Daily Meeting, 14
Direct Dealing, 15
Dealing between Centers, 16
The Problem of Language, 17
Some Foreign Exchange Terms, 18
Spot and Forward, 18
Premium and Discount, 19
Cross Rates, 20
Swaps, 21
A United Market, 22

CHAPTER 3
Foreign Exchange Five Choices, 25

Spot or Forward?, 26
Calculating the Cost of Forward Cover, 28
The Duty to Cover Forward, 28
Time Options or Swaps?, 29
Invoiding in One's Own Currency or in Foreign Currency?, 31
Exports, 31
Imports, 32
Importing from Countries with Weak Currencies, 34
Do Banks Advise or Merely Serve?, 35
Loyalty or Selection?, 36

CHAPTER 4
Money Across Frontiers, 39

The Theory of Interest Arbitrage, 39
Covered Arbitrage, 41
Practice versus Theory, 43
Hot Money, 44
The Meaning and Significance of Forward Rates, 46
Interest Arbitrage and Business Transactions, 47
Summary, 48

CHAPTER 5
Bretton Woods and After, 51

Intervention Points, 52
Intervention in the Forward Market, 54
Intervention in the Spot Market, 55
The Bretton Woods Philosophy and Its Effects; 56
The Change to Floating, 57
Crawling Pegs, 57
New Thinking, 58
Basket Currencies, 59
The Basle Agreements of July and September 1968, 61
Summary, 62

CHAPTER 6
Currency Areas and Currency Reserves, 63

The Old-Fashioned Concept of a Currency Area, 64
The Newer Concept of a Currency Area, 64
Major Currencies' Zones of Influence, 65
Reserve Currencies, 66
Is It Good to Be a Reserve Currency?, 67
The Mystique of the Lead Reserve Currency, 68

CHAPTER 7
The European Currency, 71

The Werner Plan, 72 The Snake, 74 The European Monetary System, 75 Advantages and Disadvantages, 76

CHAPTER 8

The History of Gold, 79 The Gold Pool, 81 Gold Crises, 82 Demonetization in Theory, 83 Demonetization in Practice, 83 Gold or Paper Money, 84 Prospects, 86

CHAPTER 9
World Liquidity and Special Drawing Rights, 89

What Reserves Are For, 90 How Special Drawing Rights Are Used, 91 The Future of World Liquidity, 92 Special Drawing Rights as Numeraire, 93 Special Drawing Rights as a World Currency, 94

CHAPTER 10
Currency Freedom, 97

Convertibility, 97
Why Exchange Control?, 98
The Future of Exchange Control, 101
New Insights, 101
Exchange Control—A Form of Protectionism, 102

CHAPTER 11
Capital Movements, 105

Special Rates for Money Flows, 105 The Pros and Cons, 106

CHAPTER 12 Speculators, 109

The True Gambler, 109
The Careful Insurer, 110
Whose Side Are You On?, 111
Role of the Speculator, 112
Government Interest in Speculation, 114

CHAPTER 13 The Causes of Currency Crises and Their Cure, 117

To Tell or Not to Tell, 117

Causes of Currency Crises, 119

External Troubles, 119

Organic Weakness, 120

Difficulties of Avoidance, 122

Disadvantages of Persistent Surplus, 124

Steps to Be Taken, 126

Short-Term Borrowing, 126

Public Relations, 126

Economic Reforms, 128

Controls and Restrictions, 128

Prevention of Currency Crises, 129

The World Debt Crisis, 130

CHAPTER 14 Eurodollars, 131

Origins of the Eurodollar, 133
Uses of the Eurodollar, 134
Development of the Eurodollar Market, 135
Eurobonds, 137
The Future of the Eurocurrency Markets, 138
Dangers, 140
Risks to Industry, 142
Assessment of Risk, 143

CHAPTER 15 Forecasting Exchange Rates, 145

Why Forecast?, 145 Two Approaches, 146 Method of Forecasting, 147 Timing, 148 Wisdom, 148 CHAPTER 16
Why Exchange Rates Change, 149

Inflation Rates as Indicators, 150
The Effect of Interest Rates on Exchange Rates, 151
Trade Figures and Money Flows as Major Influences, 152
Politics and Fashion in a Free Market, 153
Staying Afloat in Turbulent Seas, 154

CHAPTER 17
The Dealing Room, 157

Dealers Cannot Write, 158 Outsiders Want Information, 158 Dealers Can Deal, 159 What Makes a Good Dealer?, 160

CHAPTER 18
New Instruments, 163

Interest Rate and Currency Swaps, 164 Forward Rate Agreements, 166 Interest Rate Guarantees, 166 Cross-Market Arbitrage, 166

CHAPTER 19 Financial Futures, 169

Its Ancestors, 169
The Markets, 170
Developments, 171
Pricing, 172
Uses of Financial Futures, 172

Contents

CHAPTER 20 Currency Options, 175

What Is a Currency Option?, 175
Recent History, 176
Terminology, 177
The Risks, 178
The Main Uses of Currency Options, 178
Why Use Currency Options?, 180
Option Pricing, 180
Option Pricing Models, 182

Bibliography, 187

Glossary, 193

Index, 207

A Transport

About the author

Rudi Weisweiller has spent many years in the foreign exchange departments of two well-known merchant banks in the City of London. As Managing Director of Weisweiller Adfos Limited, he acts as a consultant and runs a variety of courses and seminars on foreign exchange. He also writes for both the technical and the general press and broadcasts regularly on financial topics.

Weisweiller is also the author of Introduction to Foreign Exchange (1984, 1990) and editor of The Foreign Exchange

Manual (1989).

A Trans

Preface

The foreign exchange market is the mechanism by which the relative values of different national currencies are established.

A great variety of transactions including foreign trade and international investment contribute to the amounts bought and sold in that market. The result is a price for foreign currencies—the exchange rate. It in turn affects living standards and capital flows, competition between trading nations, and the cost of borrowing money.

To understand this market is of course essential to its many participants; it is also important to the rest of us, because it influences the way we live and what we can and cannot afford.

This book tries to explain simply a field of activity often thought complex and obscure. It answers questions like:

Preface

What is an exchange rate?

Who fixes the price of a currency?

Who trades currencies and why?

Why do exchange rates matter?

What risks come from business denominated in another country's currency?

How can they be avoided or reduced?

Can currency dealing benefit trading companies?

How can individual investors play this market?

There are many more questions this book answers. If the explanations I offer and the information I provide are simple and clear, the purpose of this book will have been fulfilled.

CHAPTER 1

Why Foreign Exchange?

When one goes into a store and buys something which was made abroad, whether it is a Swiss watch, some French wine, a German motor car, or a Dutch cheese, one causes a foreign exchange deal to take place.

Let us use Scotch whiskey drunk in the United States as our example. There are two ways in which the businessperson who sells it in the United States can pay the distiller of the whiskey who lives in Scotland. The first way is to send U.S. dollars to Scotland. The supplier, however, cannot normally spend these in his own country and, therefore, would have to exchange them for British pounds; he has to ask a bank to change the dollars into pounds. In this case, the Scottish supplier and his banker do a

foreign exchange transaction together, each taking one kind of national money and giving the other.

There is another way of paying. Knowing that U.S. dollars are not legal tender in Scotland and that, when received from the American buyer in payment for whiskey, they have to be exchanged by him at his bank, the Scottish supplier may decide to avoid this effort with its attendant delays and expenses; he may ask the American businessperson to pay in British pounds. In other words, he invoices the whiskey to the buyer in British currency. If this is the case, it is the buyer who has to go to his bank in the United States, change some U.S. dollars into British pounds and then send these to Scotland. The foreign exchange deal has been done between the buyer and his bank in the United States.

BASIC PRINCIPLES

Whether the foreign exchange deal is done in the United States or in Great Britain does not affect the fundamental nature of the transaction. Indeed, certain basic conclusions about foreign exchange can be drawn from this or any similar example.

First, if a business transaction involving money has been concluded between residents of different currency areas, it necessarily involves a foreign exchange deal. This simple statement explains the existence of foreign exchange markets with their expensive machinery and highly paid dealers. It explains the unavoidable preoccupation of those concerned with economic problems, whether academics or politicians, with the international section of economic activity and its barometer, the balance of payments. It shows that international trade leads inevitably to foreign exchange, and that foreign exchange leads frequently to problems for nations, companies, and individuals.

Second, a foreign exchange deal is merely an exchanging of one currency or national money for another. It is like any other business deal in that one thing is exchanged for another, but it differs in that whereas usually we exchange goods for money or

money for goods, in foreign exchange money is exchanged for money.

Price

The preceding comment leads inevitably to a further point which is not without significance. If the relationship between goods and money in ordinary business transactions is expressed by the price, then this is equally true in foreign exchange: the exchange rate is the price of the one currency expressed in terms of the other. It expresses a price relationship.

There is, however, a difference in practice between exchange rates and ordinary prices which is all too rarely recognized and heeded. When an ordinary price moves up or down, one is usually entitled to seek the reason in a change in the demand for, or the supply of, the goods. For example, when peas get more expensive, this tends to be due to a shortage of supply for seasonal or special reasons, or to an increase in demand because of a change in fashion, or because alternative foodstuffs have disappeared or become more expensive.

One does not ascribe the change in the price of ordinary goods to a lessening in the value of money, unless one is either studying a large number of price increases which appear to coincide and to lack separate explanations connected with demand and supply, or comparing prices over a period of years or even decades. Only in such circumstances does it make sense to say that transit fares have gone up from the equivalent of 25 cents to 75 cents in 15 years, not because transportation is harder to organize or more costly to provide, but because money has been greatly reduced in value. It is still necessary to decide to what extent the change in fares is due to the reduction in the purchasing power of the currency, and to what extent a change in the demand/supply situation has altered the real price of the service.

The foreign exchange rate is different, even in the short run. It expresses a relationship between two national monies. It is, therefore, unrealistic to assume that changes, even over the shortest period, express alterations in the demand for, or supply of,

only one of these national monies. Whenever an exchange rate moves, this can be due to a change in the value of one or the other currency, or partly of one and partly of the other.

It is very tempting to see changes in rates of exchange as necessarily reflecting some alteration in the demand for, and supply of, our own currency, and very wrong to rejoice when our own currency appreciates or to become gloomy when its price drops. How often do we in fact look, as we should, at the economy of the country with whose currency we are comparing our own currency in the exchange rate under review? It could be that our own currency has not caused the change in the exchange rate but that events in the other country explain some or all of the change. However, comparison of the performance of both currencies with a third currency can usually throw useful light on the reasons for a movement in exchange rates, although these can be obscured by a variety of incidental factors which may be hard to isolate or analyze.

The danger of looking at only one of the two currencies covered by the currency comparison is well illustrated by a report in the press seen some time age. "Some of the selling of sterling in the morning," the newspaper article said, "was against dollars but some was against French francs, which consequently turned stronger in the afternoon." Foreign exchange language is often a deliberate attempt to make things sound more complicated than they really are. "Stronger" and "firmer" are standard ways of saving "more expensive." Therefore, all this report said was that some people were selling pounds against dollars and some were selling pounds against French francs. The French francs "consequently turned stronger in the afternoon"; in other words, they got more expensive. Why? Because if you sell pounds and buy dollars, you are increasing the demand for dollars. As some of the selling was against French francs, they were looking for French francs and bidding up the price. Pounds were getting weaker against dollars and against French francs. This report, which sounds so obscure, "some of the selling was against dollars and some was against French francs, which consequently turned stronger in the afternoon," is really stating the obvious: if you sell pounds against French francs, French francs must get more expensive.

The obscurity of the report is increased by the suggestion that pounds got cheaper against French francs in the morning and that French francs became more expensive against pounds in the afternoon. This is absurd, as the two statements are, in fact, identical and should not give the appearance of a causal relationship. These two price changes did of course take place simultaneously.

The Reason for Foreign Exchange

Foreign exchange deals exist because there are international commercial transactions. Unless people in one currency area buy from people in another currency area (and vice versa, for otherwise the balance of payments of the first area would be in an awful mess), there is no need for foreign exchange deals.

Every foreign exchange transaction carried out anywhere in the world is a link in a chain at the ends of which there are two customers who wish to exchange foreign currencies in opposite directions. It does not matter how many links are in a particular chain; the efficiency of the market is helped by the length of the chain, the multiplicity of professional middlemen or banks. It does matter, however, that at both ends of each chain stand people who are exchanging one currency for another because they themselves have done business with someone abroad. Thus every exchange deal between two banks in sterling against dollars presupposes a U.S. resident buying British goods, services, land, or investments, and a U.K. resident buying American goods, services, land, or investments.

If one of the currencies is bought by someone in a third country, this establishes no exception to the rule, as he in turn wishes only to hold such currency insofar as he or somebody else can eventually buy goods, services, land, or investments in the country whose currency he has bought.

WHOM THIS MARKET SERVES

The mention of goods, services, land, and investments brings us to a further analysis of the elementary uses of the foreign exchange market. There are four groups of reasons which bring people into the foreign exchange market as buyers or sellers of foreign currencies.

The first group of reasons is covered by the previous reference to goods, services, land, and investments. It can be covered by the term "commercial reasons" and includes such transactions as foreign travel, the purchase of foreign stocks and shares, the sale of a factory to a company in another currency area, commissions or royalties received from abroad, as well as ordinary payments for imports and receipts from exports.

The second group is closely tied to the short-term investment of spare funds in the money markets. Often these funds are moved across frontiers and into another currency only when the exchange risk can be eliminated by a contract for future delivery at the same time as the initial deal is made for immediate delivery. The theory describing the rules for this considerable volume of transactions is known as *interest arbitrage* and is described in more detail in Chapter 4.

If, however, investors seek higher returns abroad without regard to the risks of a possible change in exchange rates, we are talking of "hot money." Strictly speaking, these transactions must be included in the next group.

The third reason for entering the foreign exchange market is "speculation": the desire to buy what one does not need, but hopes later to sell at a profit to those who do; or the desire to sell for future delivery what one does not have or expect to have, but hopes to buy at a lower price before one has to deliver it. Essentially, to buy a house for oneself to live in at an opportune time and in a place which one deems likely to become more popular is a good investment; to buy a house at the same time and in the same place merely to enable one to sell at a profit and not to live in is speculation.

The uncovered movement of funds from one currency into another for a relatively short period, as mentioned above, also involves an element of risk. The attraction of higher returns at the risk of an exchange loss can perhaps be compared with moving temporarily to a house which is cheaper to run but, when sold, might fetch a price lower than the original cost of purchase.

Chapter 12 deals in more detail with the concept of speculation and some of the strong opinions people hold about it. There is no doubt, however, that some professional dealers in banks and other financial institutions or in the commodity markets worldwide have no choice but to be long or short of currencies in pursuit of the service they give their commercial customers. They would, of course, try to do so without losing money. Their activity is covered by neither of the first two categories, although it is often carried out in conjunction with deals within them.

The fourth group of reasons for people to enter into the foreign exchange market, however closely tied to the activities of traders, investors, and money men, cannot be regarded as coming legitimately within the three groups already described. Central banks of all countries which belong to the International Monetary Fund (IMF) were not only obliged to deal at the so-called intervention points for spot delivery until the changes in the statutes which followed the widespread adoption of floating exchange rates in the 1970s; they were also allowed to enter the spot or forward market at any level. Under a system of floating exchange rates as well as under the more regulated methods of arrangements like the European Monetary System (EMS) central banks intervene more frequently.

Voluntary intervention by a central bank is usually motivated by one of the following six reasons:

- 1. The central bank may be fact-finding, trying by its own action to measure the force of market trends.
- The central bank may be intent on building up its own currency reserves or those of another country, or on reducing them.
- The central bank may wish to prove that it will resist an attack on its own currency with all the reserve resources at its disposal.
- 4. The central bank may wish at times of crisis to give the impression, without being seen to do so, that its own currency is more generally wanted than it really is.

Chapter 1

- 5. The central bank may want to keep the exchange rate at a particular level in spite of market trends which, if unchecked, would move it elsewhere.
- 6. The central bank may wish to reduce violent fluctuations in exchange rates, the so-called peaks and troughs, which arise from a buildup of demand or supply due to seasonal, monetary, or political factors, and which can cause temporary rate changes of alarming magnitude. This is particularly likely under a regime of floating or partly floating exchange rates.

Whether a central bank intervenes in its own name, through another central bank, or through the offices of a commercial bank at home or abroad, will depend largely on which of the six reasons predominates at that moment. The detection by commentators of massive intervention is important to those in the market, whether bankers or their customers, and the method used by the central bank must be chosen with this fact in mind. Central banks have gained much experience of market intervention in the years since the foreign exchange markets began to reopen in the 1950s. They proceed with great skill and usually manage to serve the interests of government without destroying the viability and freedom of the foreign exchange market.

CHAPTER 2

How the Market Works

As established in Chapter 1, foreign exchange dealing is the result of international business of one kind or another. Deals only take place when people do business with someone in another country. They need to exchange one national currency for another, and this exchange is accomplished with the intervention of one or several banks. Obviously, if a number of such transactions takes place, a market is the right term for the organizational structure which results.

FOREIGN EXCHANGE DEALING SYSTEMS

The foreign exchange market differs from most markets in that it is truly and inevitably international. Foreign exchange deals do not become necessary unless people in *different* currency

Chapter 2

areas do business with each other. Indeed, in every foreign exchange deal businesspeople in two countries must be involved (see Exhibits 2.1 and 2.2).

The idea of a national foreign exchange market is, therefore, in one sense inappropriate. At best, the local market is part of an international organization, a national center for truly international activity.

In practice, as in most fields of commercial activity, those who need to exchange one currency for another rarely meet without the intervention of an intermediary. The world over, the chief intermediaries for this type of business are banks: they act as principals on their own account and seek to find another bank at home or abroad with the opposite deal in mind. It is the object of this chapter to explain how they do this.

Foreign Exchange Brokers

Within the larger of the world's foreign exchange centers, the number of banks operating foreign exchange departments makes

Exhibit 2.1. The Commercial Transaction

Transaction 1

Citizen A in Country A buys potatoes from Citizen B in Country B;

which means that

Citizen B in Country B sells potatoes to Citizen A in Country A.

Transaction 2

Citizen Alpha in Country A sells peanuts to Citizen Beta in Country B;

which means that

Citizen Beta in Country B buys peanuts from Citizen Alpha in Country A.

How the Market Works

Exhibit 2.2. The Foreign Exchange Deals

Transaction 1 and the Foreign Exchange Implications

Either Citizen A sends Currency A to Citizen B, which Citizen B then sells to a bank to obtain Currency B; or Citizen A buys Currency B with his own Currency A and then sends this Currency B to Citizen B. In either event, Currency A is sold to a bank and Currency B is thereby bought.

Transaction 2 and the Foreign Exchange Implications

Either Citizen Alpha receives Currency A, which Citizen Beta has bought from a bank with his own Currency B; or Citizen Alpha receives Currency B from Citizen Beta and sells it to a bank to obtain Currency A. In either event, Currency A is bought from a bank and Currency B is thereby sold.

The Result of the Transactions

With the help of banks (the foreign exchange market), two foreign exchange deals (which resulted from two commercial deals) have been carried out. They are in opposite directions. If they are also equal in size, the balance of trade is in equilibrium and the currency reserves of Countries A and B neither gain nor lose.

necessary a highly developed and efficient system of foreign exchange brokers to act as go-betweens in the foreign exchange deals which any of the banks may wish to enter into with any of their neighbors. Although not all banks maintain active dealing rooms, the markets are of a size and versatility in which only a measure of specialization and high degree of organization can avoid chaos and frustration. Brokers, therefore, act between banks within countries and across the world.

The rules of the market are simple. The foreign exchange brokers are somewhat like brokers on a stock exchange, but they do not usually act as principals. They inform and introduce; when business between two banks results, they confirm the arrangement and collect a brokerage. In recent years many firms of foreign exchange brokers have either established branches in other centers or entered into long-term affiliations with existing firms abroad. This enables them to act as links between banks in different countries and even continents, thus making the concept of a worldwide market both easier to achieve in practice and less costly in terms of rapid communication than was possible when banks relied entirely on direct dealing for their currency deals with banks overseas.

The basic function performed by foreign exchange brokers is to tell banks the rate at which there are firm buyers and firm sellers available in the market at any time. They will give this information in reply to a specific inquiry from a particular bank about a pair of currencies to be exchanged, either for spot delivery or for a stated forward date. They will also offer this information unasked to some or all of the banks with whom they are in regular contact, whenever a change in the rate or some other event makes them feel that such information may be of use to the dealers in the banks or bring them additional orders from the dealers.

When a foreign exchange dealer in a bank wishes to buy or sell foreign currency, he can give one of the brokers specializing in that currency an order to buy or sell which will be for a stated amount at a stated price or within a stated limit and which will be valid until explicitly withdrawn or until a stated time. The broker immediately informs the banks with whom he is in regular contact—and to whose dealing rooms he has usually one or several direct telephone lines—of the proposition made. At this stage he does not give the name of the originator or any hint of his identity. Exceptions are sometimes allowed, however, when the originator is, at one extreme, a central bank or, at the other extreme, a small bank wishing to deal in an exceptionally large amount or for delivery a long time ahead. Known or suspected limits affecting particular names may also justify disclosure, especially where forward deals or deposit business are involved.

The broker will receive varying reactions to his proposal, and with those who show some interest he will talk further. After checking the whole market and perhaps negotiating with a few banks he may revert to the originator with a firm counterproposal.

How the Market Works

If two banks eventually agree to deal, the broker will tell each the name of the other. A confirmation and a bill for brokerage will be sent to both of them by the broker, who may tell all the other banks on his circuit that business was done and at what price. He will still not tell them the names of the two banks involved.

It is one of the main activities of brokers to tell the banks at what rates business has recently been transacted or is now proposed. The system assures banks of the speedy and anonymous passing of information to all members of the market, and this is the chief advantage of the brokers' system. Considering the small amount of time and effort which banks have to contribute to the achievement of individual deals, the brokerage charged does not seem excessive.

There is another and valuable way in which banks can and do use the brokers and which, provided the brokers are fully in the picture all the time (which is feasible and probable when a large proposition of the total business passes through the brokers). Dealers ask the brokers for information even when they have no immediate proposition to make. While brokers obviously hope for some orders with a prospect of actual brokerage-earning business, they will also readily tell dealers what is going on elsewhere in the market. The dealer who has inquiries from industrial customers or from abroad relies heavily on such information long before he has himself done a deal, and thus is in a position to give an order to a broker in cover thereof. This function of the brokers' market as a source of accurate and up-to-the-minute information is a very important aspect of the system.

Deposit Brokers

The development of the Eurocurrency markets, described in greater detail in Chapter 14, has brought a new activity to the dealing rooms of most banks and one which has grown rapidly since its inception in the late 1950s.

Banks borrow from and lend to industrial firms of various sizes (commercial and central banks, state agencies and interna-

tional organizations) large amounts of currencies other than their own. This business is really more appropriate to the cashier's department or the credit officers of the bank than to the foreign exchange traders. Nevertheless, it has become customary to leave foreign exchange dealers to handle it because they tend to have the necessary knowledge of the overseas banking and commercial scene, are in frequent contact with likely partners abroad, and often speak several foreign languages.

In these activities foreign exchange dealers have increasingly utilized the services of foreign currency deposit brokers to find them suitable counterparties in their own center or elsewhere, to check credit-standing and limit-availability, and to fix up business. Where loans result, both parties pay a fixed brokerage.

Many of the foreign exchange deposit brokers are firms which also operate as ordinary foreign exchange brokers, but usually different teams working in separate rooms attend to these two activities. Close contact is necessary as foreign exchange swaps frequently connect a borrowing activity in one currency and a lending activity in another. The essential difference between buying and selling on the one hand and borrowing and lending on the other hand must, however, never be forgotten.

The Daily Meeting

Many European countries have a foreign exchange market which, for part of each day, (unlike the telephonic markets in New York, London, Tokyo, Singapore, or Hong Kong), has also a physical meeting-place, generally in a special room within the building of the local stock exchange. This physical foreign exchange market is not customary in English-speaking countries and, therefore, has no name in the English language. Dealers refer to it as the *foreign exchange bourse* or the *fixing*.

Those who are used to operating on a foreign exchange bourse find this system quick and efficient. Others regard it as merely time wasting and noisy; it certainly makes anonymity

How the Market Works

impossible by forcing dealers to make their bids and offers in public. One of the accidental advantages of the bourse system is, however, the opportunity it provides for dealers to meet frequently and to get to know one another. For dealers in markets without such physical marketplaces the best way of becoming personally acquainted is provided by the International Foreign Exchange Club founded through the initiative of a Frenchman, Maurice Plaquet, in the late 1950s. This club provides national and international gatherings for social contact and professional discussion.

The bourse operates much like a stock exchange or commodity market. Like these, it has one great advantage: the final price of the day, based on the business actually brought into the market, is made public immediately. Not only can it be used as a basis for legal agreements, but in many countries it also forms the basis for the exchange rates used between banks and their customers.

No such norm exists in the United States or the United Kingdom, so there is room for negotiation between customer and bank and for misgivings after the deal has been done. Legal problems also arise from the difficulty of defining precisely "the exchange rate of the day."

Direct Dealing

The other method used for foreign exchange dealing between banks in the same center is for the dealers of one bank to get in touch by telephone or by telex with the dealers of another bank. At one point, this system was the only one used in Switzerland and it was workable because there were relatively few, although large and active, foreign exchange dealing rooms in that country. It seems cumbersome for banks to operate without the aid of either brokers or a physical meeting place, but some foreign exchange dealers are accustomed to this system and prefer it.

Most European foreign exchange markets use a combination of the three systems: the daily meeting, direct dealing, and brokers. They meet once a day at the central exchange, but before and after the daily meeting, while in their respective offices, they get in touch with each other by telephone, fax, or telex. In most countries there are now brokers who attempt to fix up deals between two local banks, or between two out-of-town banks, or between a local bank and an out-of-town bank.

In some centers in continental Europe the brokers tend to be offered a large number of proposals that are difficult or impossible to turn into brokerage-earning deals. Some brokers are compensated for this disadvantage by serving in an official capacity at the daily fixing, thereby earning handsome commissions.

DEALING BETWEEN CENTERS

Thus far our attention has been focused mainly on the different ways in which banks in a financial center communicate with each other, convey or obtain information, and negotiate foreign exchange deals between members of the same market, therefore enduring that, apart from minor variations, the same price will be asked and offered for the same currency by all banks in the same country at any one time. We must now turn our attention to international deals, which are after all the fundamental ones in terms of the service rendered by the foreign exchange markets to those taking part in international trade and investment.

A large proportion of the foreign exchange deals done each day is between banks in different countries. These deals are often the direct consequence of the wishes of the banks' customers to buy or sell currencies needed to pay for goods or services or received in payment of goods or services. Others are between the banks only and do not have an immediate commercial transaction underlying them; they serve to even out temporary differences in the level of demand and supply in various centers and to ensure that at any one time the rate for a certain currency is the same, not only everywhere in one country, but everywhere in the world. It is necessary to add that "the world" to the foreign exchange professional means those parts of it which are awake and working at that time of day.

When banks wish to be in touch with others with whom they maintain a regular business relationship to discuss foreign exchange matters, to seek or give information, to make bids or offers for currencies, to negotiate deals, or to borrow or lend currencies, their dealers will usually approach them by telephone, fax, or telex or through a broker. The method chosen will depend on technical circumstances such as cost, degree of urgency, or the availability of lines and machines, as well as the inclination of the dealers involved, depending on the particular purpose of the call and the type of discussion expected. Where poor connections or linguistic difficulties are feared, the telex, fax, or the broker will be preferred to the telephone. Where hard bargaining is expected, persuasion needed, or general information sought, the telephone may prove the most satisfactory.

THE PROBLEM OF LANGUAGE

As so much of the foreign exchange dealer's life is lived on the telephone, fax, and telex, and most of it on calls where distances are great and costs therefore high, it is only natural that a distinct language should have developed between the world's relatively few foreign exchange professionals. Time is money for the foreign exchange dealer in a more direct sense than for everybody else.

The foreign exchange vocabulary consists of two kinds of words: those which are the proper technical terms of the trade and, far more numerous, those which have developed and are used in conversations between the professionals.

The words in this second group should not be used when explaining foreign exchange matters to customers, to nonforeign-exchange people in the banks, or to journalists. They are used all to often outside the market and cause obscurity. This leads to a failure in communication. The consequences of this include a widespread belief in the obscurity of all topics related to foreign exchange and sometimes an inability on the part of customers to obtain urgently needed help and advice in this field of banking.

Dealers ought to be aware of the importance of lucid explanation in terms intelligible to the uninitiated when discussing foreign exchange matters to those outside the market, and of the unfortunate results, upon their own careers as well as upon the business of their customers, if they fail to translate their expert knowledge into the native idiom. A complete glossary of foreign exchange and related terms is found at the end of this book.

SOME FOREIGN EXCHANGE TERMS

There are several unavoidable foreign exchange terms with which even the nonexpert must be familiar if his work involves him in serious confrontation with the subject, whether for political or commercial reasons. Six of these terms are dealt with here, namely spot and forward, premium and discount, cross rates, and swaps.

Spot and Forward

All foreign exchange contracts entered into by two parties, whether they are bankers or not, are legally binding, whether oral or written, and are for a specific value date. On this date, delivery of one currency will be made by A to B and of the other currency by B to A. The value date is also called the delivery date. It is important, and sometimes frankly irritating, that delivery of both currencies must be made on the same day and that, because of this, contracts can only be made for a date which is a "good date" or working day in the countries of both currencies. For example, Good Friday is not usually a holiday in New York, but it is impossible to buy U.S. dollars for delivery on Good Friday with pounds, because it is a holiday in the United Kingdom and, therefore, one of the currencies cannot be delivered.

This problem apart, currency deals can be agreed on for any working day that suits both parties to the contract. It can be as far in the future as desired, although few contracts are for periods over one year and, even in the most important currencies, deals

How the Market Works

are rare for delivery dates beyond five years. Deals are known as forward deals unless they are for delivery within the next few days, in which case they are called spot deals. Here it is necessary to differentiate between "spot" as meaning any delivery within the next few days and "spot" (as more usually understood) as meaning delivery two-working days from today. This latter and better-known interpretation of "spot" should really be called ordinary spot.

Premium and Discount

The price of any currency for different delivery dates tends to vary even at the same moment. In Chapters 3 and 4 we will discuss both why this is so and some of the reasons which might influence buyers or sellers to cover for a particular delivery date even at prices which look unattractive. For the moment we are concerned with the fact of these differences, not with the whys and wherefores.

When foreign currencies for different dates are being traded at different prices, these differences are expressed with reference to the price for ordinary spot (two-day delivery). If the currency in question is more expensive for forward delivery than for ordinary spot, it is said to be at a premium. If it is cheaper, it is said to be at a discount.

An example will show how this difference between the price for spot delivery and the price for forward delivery shows in the quoted exchange rate:

Spot sterling: \$1.50 per £ (also written as \$1.5000)
 Forward sterling for three months: \$1.49 ½ per £ (also written as \$1.4950)

The difference of ½ cent or 50 points measures the discount for three months forward as compared with spot: forward sterling is cheaper than spot, that is, it costs fewer dollars.

2. Spot sterling: Forward sterling for three months: \$1.50 ½ (also written as \$1.5050)

The difference of ½ cent or 50 points measures the *premium* for three months forward as compared with spot: forward sterling is more expensive than spot, that is, it costs more dollars.

It is also true that the opposite statements are appropriate if the spot/forward relationship is viewed from the standpoint of the other currency involved. In the preceding example, the forward dollar is at a premium if forward sterling is at a discount, the forward dollar is at a discount if forward sterling is at a premium.

The same applies if we study and compare any other pair of currencies, for example, dollars and marks, dollars and yen, pounds and Swiss francs, Italian lire and Dutch guilders, and so on.

Cross Rates

It is normal for customers to approach their bank's foreign exchange department to buy a foreign currency against their own or to sell a foreign currency against their own. There are, however, exceptions when for some reason one foreign currency is traded against another. Such deals are known as cross deals and the price that is quoted is known as a cross rate. Whereas there are many cross rates (Dutch guilders against Japanese yen, French francs against Spanish pesetas, etc.), the term "the cross rate" was in the past used by European dealers for the price of Canadian dollars in terms of U.S. dollars.

It is worth bearing in mind that the cross rate depends on the viewpoint of the beholder; what might be a cross rate to an Italian, for example, Swiss francs against Belgian francs, would not be a cross rate to either a Belgian or a Swiss.

Today's dealers in almost all parts of the world quote most exchange rates against the U.S. dollar, a mathematical conversion has to take place to establish the price of those currencies in terms of the dealer's home currency. Strictly speaking, the rate of the
foreign currency against the dollar is a cross rate to dealers in third countries.

Swaps

A swap is a pair of foreign exchange deals in the same two currencies but for different delivery dates and in opposite directions. Often both the deals constituting the pair are entered into by the same two partners, but this need not be so. The amounts involved will be identical for one of the currencies and similar for the other, the difference here being the result of the difference in exchange rates for different dates.

A swap for £100.000 against dollars, spot against forward, might consist of these two deals: on February 1, A sells to B £100.000 for delivery on February 3 at \$1.50 and buys from B £100.000 for delivery on May 3 at \$1.49. This is a swap. Both legs of it were done by A with the same partner, but in the second deal C could have taken the place of B and the pair of transactions would still have been a swap as far as A is concerned. The amount of dollars received by A on February 3 is \$150.000 and the amount given by him on May 3 is only \$149.000 because the dollar is at a premium (i.e., is more valuable) for forward delivery and sterling is at a discount (i.e., is less valuable). In this example the amounts of one currency (sterling) are identical (£100.000), while the amounts of the other currency (dollars) are similar (\$150.000 and \$149.000).

Swaps take place between commercial customers and their bankers, or between banks, or between governments, when it is desired to move out of one currency into another for a limited period and without incurring the exchange risk of an open position in either of them. By doing the later deal at the same time as the earlier one, the exchange risk is avoided.

This is useful when it is desired to alter the date of receipt or payment rather than cancel it altogether. The most obvious examples are those occurring when banks use swaps to match long and short positions which are identical in size but for different delivery dates, or when customers use swaps to move exchange contracts done some time ago on a forward basis from the original and provisional delivery date to the one actually required.

The swaps arranged between central banks are, perhaps less obviously, a similar tool for changing the date rather than for altering the fact of payments due: they neither increase nor reduce the exchange risks involved in the country's balance-of-payments position, nor do they improve the reserves in real terms. They are, nevertheless, an attractive device for dealing short term with an existing shortage of currency reserves.

A UNITED MARKET

The problem of language leads unfortunately and regrettably to misunderstandings. These do occur even though foreign exchange dealers take great trouble to avoid them by repeating what they believe they have done, in different words or in a different language, before the end of the telephone conversation. If in serious doubt, they confirm it via fax or telex before time has made a change in the rate probable.

Nevertheless, situations do occasionally arise in which two dealers sincerely and firmly believe different facts about the same conversation and contract. It has become quite common to record telephonic deals, but if this has not been done or is not conclusive, it is usual and right to share equally the damage done to one or the other of the parties and not to maintain an adamant belief in personal infallibility. The principle underlying this custom is that banks wish to continue to do foreign exchange business together and that this makes it necessary to respect the convictions, however mistaken, of one's partners.

The same desire for an agreeable business relationship in the longer run also explains why dealers will bargain hard and persistently but will never cheat their counterparts. Furthermore, they practice a measure of mutual help in professional difficulties that often astonishes outsiders: sometimes they do deals which do not suit them, merely to oblige a dealer in another country; at other

How the Market Works

times they will lean over backward to assist a trainee dealer in another bank and to prevent his making a costly mistake.

These facts point to the solidarity of the foreign exchange community, to the spirit of eager yet friendly competition, and to the understandable enjoyment of an activity both exhausting and stimulating. The resulting loyalty to the profession and to its members is well summarized by the motto of the International Foreign Exchange Club: "Once a dealer, always a dealer."

CHAPTER 3

Foreign Exchange Five Choices

The businessperson who has to divert some of his time to foreign exchange problems will sometimes need and seek information. Most often he will be confronted with actual choices and will be aware of the financial importance of deciding on the right course of action or inaction. Which problems confront him will depend on whether he is concerned mainly with imports or with exports, with overseas investments, or with the purchase of raw materials or factory installations from abroad.

This chapter selects five of the most common of these choices or problems, not on the grounds that they are necessarily the most difficult or most interesting, but because they have the most relevance for the largest number of executives in industrial and commercial firms.

SPOT OR FORWARD?

Should those who have entered into a firm commercial commitment to buy from abroad and pay in foreign currency, or to sell abroad and receive foreign currency, cover the currency straight away on a forward basis or should they wait until the time of payment or receipt and then cover it on a spot basis?

In some countries exchange control does restrict the businessperson's choice. In others there is no such control at all or the exchange control regulations leave the choice to the individual or company: to cover forward or not to cover forward. It is therefore important to consider what factors should influence decisions in this matter.

Covering forward is a form of insurance. Those whose total reserves are limited and for whom it is vital that the price of a particular installation or raw material or sale of goods shall not be affected adversely by a change in the exchange rate may see no alternative to covering forward. Costs and probabilities may both incline them to take the risk, but normal commercial *prudence* suggests that forward cover is necessary.

Many bankers expand this view to the admonition that all their customers should cover forward all commercial commitments. The arguments advanced in favor of this all-embracing rule are: (1) that the job of the customer is to think about his trade or production and not about foreign exchange; (2) that the banks provide a professional service which customers should use without involving themselves in difficult technical considerations. This rule, while reasonable for the small business, is not tenable for the more sophisticated company with frequent and substantial involvement in international transactions. To such a company the argument is like not interviewing a prospective secretary because one's business is the manufacture of shoes and not the assessment of personnel.

If the decision—whether to cover forward or not—has to be taken, it would be helpful to have some general rules as a guide. Unfortunately, the needs of no two companies are identical, nor are the risks or the cost of cover the same in any two weeks of the

Foreign Exchange Five Choices

year. It is, at best, possible to list some of the relevant questions to be asked and to suggest that they be answered and the decisions reviewed every few months, especially whenever a particularly big deal is contemplated or when an international development affecting currencies merits special attention.

- 1. Is it likely that the currency I have to buy will be upvalued or will float upward before the time of payment (or that the currency I will have to sell will be devalued or will float downward)?
- 2. Is my own currency likely to change its official parity or actual exchange rate against some, many, or all foreign currencies or to float outside present limits?
- 3. Is the foreign currency or my own currency likely to be involved in any general realignment of rates during this period, such as occurs in the European Monetary System (EMS) from time to time?
- 4. How might the foreign currency or my own currency fare if there are further changes in the international monetary system, such as the introduction of new intervention points or the extension of floating rates or the refixing of now freely floating currencies?
- 5. What is the most that the changes feared (whether likely or unlikely to occur) will cost me in actual cash?
- 6. What is the cost of forward cover (the difference between spot now and forward now) in actual cash?
- 7. What is (a) the likely and (b) the possible improvement or worsening in the spot rate between now and the end of the period?
- 8. Is the forward rate, as sometimes happens, actually more favorable than the spot rate, so that forward cover is desirable even though the risks (see prior Questions) are deemed insufficient to justify insurance?

Nobody denies that it is difficult to answer these questions with any degree of accuracy. The costs of forward cover, and the losses consequent upon an exposed position, are, however, such as to merit careful consideration in making the appropriate decisions. These decisions do not always remain valid for long and therefore need frequent and careful review.

Calculating the Cost of Forward Cover

Spot sterling/dollar:

\$1.50 = £1

three months' forward:

seen from the United States:

1 ½ cents discount

 $= $1.48 \frac{1}{2} = £1$

seen from the United Kingdom:

1 ½ cents premium

 $= $1.48 \frac{1}{2} = £1$

Contracting to buy the pounds three months before payment is due therefore costs 1 ½ cents less, that is, \$1.48 ½ per pound (whereas at the present rate for spot it would cost \$1.50 and the actual rate for spot in three months' time is of course unknown).

The result of the decision—whether to cover forward or not—will remain unknown until the three months have passed and the new spot rate is known.

The Duty to Cover Forward

In an age of generally floating exchange rates and the resulting exchange rate fluctuations, the profit on a commercial transaction which relies heavily on overseas raw materials or overseas sales can be wiped out or doubled. To ask the question "Should we cover forward?" and to answer it correctly is therefore vital not only to the fate of a particular transaction but sometimes even to the very existence of a company. The banker therefore has both a right and a duty to advise his customer expertly and wisely in this matter. Companies should never take avoidable exchange risks.

The following principles can be applied to decisions in this area:

- 1. If you have already bought in one currency and have already sold in another currency, cover forward.
- 2. Deviate from 1 above if you see no danger ahead or only the likelihood of a change in your favor and if the amount is small in relation to your total trade. Deviate only if you are sure that your knowledge is sufficient and your advice good. Do this rarely and only in special circumstances.

If, however, you have already bought in a currency and have yet to sell in another currency (or have already sold in one currency and have yet to buy in another currency), the decision whether you should obtain forward cover immediately or not is more difficult. If you regard an adverse change in the rate of exchange as likely, you will, of course, cover forward now. If, however, you expect no change, or even one which favors you, you may be justified in leaving the position open: if you cover at the wrong moment you enable a luckier competitor to ruin you. In this type of situation there is no moral merit in covering forward as against not covering forward: in either case you are taking an unavoidable risk which contains a large speculative element and is probably an inevitable part of your business.

TIME OPTIONS OR SWAPS?

Those who cover their currency commitments by making purchases or sales of currency for forward delivery frequently have to face the fact that the exact date when the foreign currency will be needed (in the case of imports) or received (in the case of exports) is not known at the time the commercial contract is signed and forward cover is arranged.

There exists a choice of methods to deal with this problem. The easiest way, although not usually the least costly, is to obtain from the bank a time option forward contract. This fixes the rate of exchange irrevocably but leaves the exact delivery date to be decided later by the customer. (As in all foreign exchange deals, the foreign currency and the domestic currency are paid on the same day, making a true exchange. The domestic currency is paid on the day when the foreign currency is really wanted, or received on the day on which the foreign currency becomes available.)

This is clearly advantageous, but not cheap. The customer has to pay the bank for the privilege of not fixing the delivery date when the foreign exchange deal is done; the cost of such an option contract is the premium or discount ruling at the time the contract is made for the most costly of the delivery dates within the customer's range.

For this reason the customer looks for an alternative way of covering forward, even though the exact date of delivery is unknown at the time the forward deal is done. This way is to cover forward for an arbitrarily selected but fixed date and later to adjust this by means of a swap. In most cases this proves cheaper than a time option contract.

The adjusting swap in fact consists of a pair of exchange deals between the customer and the bank, as described in some detail in Chapter 2. One half or "leg" of the swap is for the delivery date of the original forward contract and is in the opposite direction. The other leg is for the desired new delivery date and is in the same direction as the original forward contract. Thus the delivery date is moved from the presumptive to the actual date of payment or receipt.

The comparative advantages and disadvantages of time options on the one hand and of fixed contracts followed by swaps on the other are easily listed.

1. Time option contracts are costly, but they give complete protection against exchange risks. Fixed contracts followed by adjusting swaps give only partial protection, but they tend to work out cheaper. Indeed, the only circumstances in which they present a risk are if the premium or

Foreign Exchange Five Choices

discount changes adversely between the date of original contract and the date of adjustment. This occurs during periods of currency speculation or when interest rates in one of the two countries have changed considerably.

2. Both are fairly predictable in the short term. The cost of a swap for a short actual span of time rarely exceeds the cost of the time option for the longer presumed span of time. At the same time, however, a complete breakdown in the forward market could prevent the adjusting swap technique being used.

Those with a fair volume of business, adequate foreign exchange staff, and the will to take small risks often show a preference for the fixed-date forward contract followed by an adjusting swap rather than for the generally more expensive but safer time option contract.

INVOIDING IN ONE'S OWN CURRENCY OR IN FOREIGN CURRENCY?

In the preceding paragraphs we were concerned with invoices (received or issued) in the currency of another country. Many firms buy and sell on the basis of contracts expressed in their own currency. This corresponds to long-established practice in many industries and saves both work and worry for one partner in such transactions: conversion into foreign currency is not his problem and exchange risks do not, on the face of it, concern him. Yet there are situations in which firms should consider currency invoicing as an alternative. Let us, therefore, examine the possible advantages of such a change.

Exports

The practice of issuing invoices in foreign currency for exports has received much publicity in recent years. Given certain conditions it can increase profitability by obtaining for the pro-

ceeds of goods a rate of exchange that is better than either the present spot rate or the likely future spot rate.

This is only true if

- 1. There is a reliable forward market for the currency in question
- 2. The foreign currency is traded forward at a premium against the exporter's own currency
- The exporter tends to receive payment a long time after the receipt of orders (which is when he is able to sell the proceeds forward)

Clearly, a premium of 2 percent or 3 percent per annum makes currency invoicing coupled with forward sale of the proceeds more interesting than a premium of only ½ percent or 1 percent per annum. Equally, if a delay of two years between receipt of order and receipt of payment is expected, bigger savings may be shown through forward cover than would be the case over a period of only three or six months.

In any event, currency invoicing coupled with forward sale of the proceeds exposes the exporter to no greater exchange risk than invoicing in his own currency, provided of course that he is assured, through sufficiently trained staff, of prompt action in the forward market as soon as a commercial contract in foreign currency is entered into. If, however, the buyer of the goods is alert to currency matters, he may prefer to be invoiced in the exporter's own currency so that he can buy it forward at a discount as soon as he has placed the order for the goods. The buyer would thus benefit from the differential between spot and forward, and prevent the seller from doing so.

Imports

It is even more interesting to analyze a transaction in the opposite direction, because one might assume at first sight that the importer who receives an invoice in his own currency has no

worries and ought to be delighted with the simplicity of the paying procedure. There are, however, three situations which might cause him to regret that he has to pay in his own currency.

First, if the foreign currency which he considers a reasonable alternative to his own currency for a particular transaction happens to be at a substantial discount against his own currency, he can cheapen his imports by paying in that foreign currency and buying it forward. He does not usually add to his risks by doing so but there is likely to be a delay between his agreeing to be invoiced in a foreign currency and his actually receiving and accepting the quotation, a delay during which a change in forward rates could be damaging. It is wise to ask for two quotations, one in his own currency and one in foreign currency, and to calculate at the time of ordering which one would be cheaper in real terms.

Second, if foreign suppliers are willing to invoice importers in the importer's own currency but insist on a guarantee against the effects of a devaluation of that currency, it is better to refuse to do so and to ask to be invoiced instead in a foreign currency which can be bought forward. An importer can, in the case of currency invoicing, ensure against the risk of devaluation by covering forward; the consequences of the guarantee cannot always be avoided by a protecting deal in the forward market.

Third, many suppliers who are willing to invoice importers in the importer's currency remember previous devaluations and are fearful of the loss they would suffer if this calamity were to recur. They therefore add a percentage to the price per unit. Where this percentage is similar to the actual cost of forward cover at that moment there cannot be much objection. It has been the experience of some large importers in such countries, however, that the percentage added has not been on that scale but in the region of five or ten times that (e.g., 5 percent per annum instead of ½ percent per annum). Such terms have been proposed on the grounds that they might well represent the cost of forward cover by the time the supplier realized that a renewed crisis was imminent. In such cases it is clearly better for the importer to accept invoices in a foreign currency for which there is an adequate

Chapter 3

forward market and to buy such forward cover as he sees fit. If he is situated near one of the world's larger foreign exchange markets, he should be able to judge the risks much better and buy cover far more cheaply in most instances than some of his suppliers.

Importing from Countries with Weak Currencies

When one's own currency is traded forward at a premium it is the importer, not the exporter, who can enhance his profits by offering to pay in the supplier's currency. If that currency is traded forward at a discount (as, for instance, sterling or the French franc often are against the U.S. dollar), he can buy it forward as soon as he has ordered the goods and can thus get it more cheaply.

A hypothetical transaction looks as follows, assuming payment by an American importer for British goods due one year after ordering the goods.

Sterling price	£1,000 per ton
Discount for one year sterling (about	6 cents per
4 percent per annum)	pound
Spot £/\$ rate	\$1.50 per pound
Forward £/\$ rate	\$1.44 per pound
Spot price per ton	\$1,500
Forward price per ton	\$1,440
Saving on 1,000 tons if the spot rate	
does not drop	\$60,000
Saving on 1,000 tons if the spot rate	
drops to \$1.45 per £	\$10,000
Loss on 1,000 tons if the spot rate	
drops to \$1.40	\$40,000

The importer will be aware that contracting to pay in foreign currency and covering the currency commitment forward is safe (as safe as contracting to pay in his own currency) and may be profitable, whereas contracting to pay in foreign currency and not covering the currency commitment forward involves an exchange risk.

DO BANKS ADVISE OR MERELY SERVE?

There is a considerable divergence of opinion among bankers and their customers as to the precise role of the foreign exchange departments of the banks. These bankers' main function is undeniably to serve their customers by buying and selling foreign exchange whenever required, at reasonable rates and in a way that minimizes the risks, troubles, and delays that might befall those whose business involves foreign exchange. This service is of a high degree of excellence and can be obtained from a very large number of banks. Volume of turnover, geographical specialization, and the experience of individual foreign exchange dealers may, at times, give certain houses a marginal advantage over others, but all banks will act quickly and obtain similar rates because the foreign exchange market is organized to make this possible. Information about the borrowing and lending of foreign currencies, exchange control regulations in various countries, payment methods, existing rates, the availability of forward cover, and any other factual aspects of foreign exchange will all be readily available. Permission will be obtained where necessary, and payments reliably and speedily made. Service is the aim, and this aim is achieved.

Some banks also offer advice on whether forward cover should be taken or not, or on whether transactions should be speeded up or delayed because of probable changes in the rate of exchange of the currencies chosen for purchases or sales. Other banks try to avoid doing so, explaining that their duty is to do what their customers ask them to do efficiently, speedily, and cheaply, and not to tell the customers what to ask them to do. This unwillingness to include real advice in the service offered is justified by arguments which are varied and generally valid. The

banks are rightly afraid of being misrepresented or misinterpreted. They regard it as a presumption to appear definite in matters which are merely opinions and in areas which are exceedingly difficult to assess. The banks believe that businesspeople must make their own decisions and that they cannot delegate this obligation.

All this is true. The difficulty seems to arise from a misunderstanding of the concept of advice. No sensible person would expect bankers to tell customers what to do or customers blindly to obey such orders. Rather, customers should seek the opinions of the foreign exchange experts in the bank, which surely ought to be if not wiser at least much deeper than the opinions most customers can hope to form during a daily routine that is much more remote from the professional currency world. The professionals ought to be able and willing to offer such opinions to customers readily, clearly, and fairly.

This service is an essential part of the work of a good foreign exchange department. It is obvious that the customer, having heard what one or several professionals have to say, will make up his own mind and will buy or not buy, or sell or not sell (of course within the actual regulations and market possibilities). The bank advises; the customer decides; the bank then acts on his behalf.

LOYALTY OR SELECTION?

Those who buy or sell foreign exchange, especially for forward delivery, sometimes wonder whether they should obtain and accept quotations from only one bank and hope that they are being looked after as loyal customers of long standing. Or should they "shop around," asking several banks for quotations each time and accepting the best, possibly after prolonged and vigorous argument with several of them?

The advantage of shopping around is that is keeps the customer and banker in a healthily competitive frame of mind. In extreme cases it discloses grossly exaggerated dealing margins habitually claimed by a very small minority of banks. In most

cases it unearths only slight variations, particularly where quotations for spot delivery are concerned.

When rates fluctuate violently, which often happens where there is a system of floating exchange rates, comparisons are meaningful only if they are simultaneous: even a one-minute difference between the times of two inquiries may invalidate this exercise.

A further snag about shopping around is that it costs money. An out-of-town customer making three telephone calls to obtain rates from different banks and three more calls to accept or reject those rates runs up telephone costs and uses executive time at a level unlikely to be justified by the improved exchange rate thus achieved, unless the amounts involved are very large. Few firms, in their commendable eagerness to get the best possible rates, seem to calculate this.

It is also the experience of those who shop around that, after a while, none of the dealers approached gives quite the same detailed attention to them as they do to others who are less critical and rely more obviously upon the services of their own bank.

That the blandishments—in the form of superlatively attractive exchange rates—which are sometimes used to lure foreign exchange customers from their present bank are not kept up once the customer has been won over is the sad experience of many an overeager executive. He may well appreciate also, when it is too late, the apparent effortlessness with which his regular bankers carried out complicated payment instructions.

It can be concluded that it is right and expedient to shop around at times, both to confirm that one is adequately looked after by one's own bank and to assure oneself of the best rate in a particular case. However, this is worth doing only for items of an exceptional nature or size, although what may seem large for many firms is not big enough in foreign exchange terms to merit expensive checking on every occasion.

A final word of warning is perhaps not out of place before leaving this topic. When customers ask banks to hold a spot exchange rate firm for even five minutes, they are forcing a dealer who knows his job to take an additional margin of several points to

Chapter 3

provide himself with a cushion against violent short-term movements in the rate. The result for the customer tends to be that the best of three rates obtained on a "good for five minutes" basis (enabling him to shop around at leisure) is worse for him than the worst of three rates obtained on a "for immediate reply" basis.

CHAPTER 4

Money Across Frontiers

This chapter deals with the interrelationship between the foreign exchange market and the money market and between foreign exchange rates and interest rates. It revolves around the theory of interest arbitrage.

THE THEORY OF INTEREST ARBITRAGE

The theory of interest arbitrage states that interest rates for comparable short-term investments in different countries and currencies must differ by the same amount as the spot exchange rate differs from the forward exchange rate. It does not say that the exchange rate difference follows the interest rate difference, nor that the interest rate difference follows the exchange rate difference. All it says is that a change in either of them will be reflected by a corresponding change in the other. This is a startling statement with important practical consequences. It is true and therefore worthy of closer examination.

When investors or savers, company treasurers or bank vice-presidents, or any other holder of liquid funds consider how best to employ them, the foremost consideration will be the safety of the money. They need to be certain that the standing of the borrower is such as to remove any reasonable fear of default. In certain parts of the world they will also have to take into account the possibility of political changes restricting the potential borrower's freedom to repay. Only when these factors have been examined and judged can lenders legitimately interest themselves in the comparative return offered them by different types of borrowers, or indeed by different borrowers of similar type.

Within a single country this is the way short-term money is placed. However, when borrower and lender are situated in different countries, or more precisely in different currency areas, an added complication arises: one of the two has to operate in a foreign currency and therefore must bear the risks of an adverse change in the exchange rate throughout the period of the loan. If the lender insists on lending his own currency, then the borrower will worry lest the currency borrowed appreciates before he repays, thus making the borrowing more expensive than the rate of interest taken by itself. If the borrower is able to insist on borrowing and owing the money in terms of his own currency and this currency loses in comparative value before he repays, then the lender will receive back less of his own currency than he lent; the total return on his money in this case would be less than the agreed rate of interest.

In the face of these facts it is surprising how many people still believe that vast short-term funds move to another currency area in response to a marginally higher rate of interest. Changes in domestic rates certainly have some influence in attracting or not attracting foreign money, or in allowing domestic funds to be tempted or not tempted to go abroad. The extent to which this happens, however, is much less than is often implied by statements made at times of currency crisis or when interest rates change. Most managers of short-term funds would not feel justified in exposing themselves to the risk of a change in exchange rates.

The unexpected occurrence, or at least unpredictable timing, of changes in exchange rates causes losses to those whose funds cross currency frontiers without precautions, losses which have been substantial enough in the past to make this practice less and less common. "Hot money" of this kind is not the regular feature of money markets that it once was, and commentators should recognize this. In today's market big movements of money across frontiers are more often motivated by expectations of a favorable change in the rate of exchange than by the additional earning prospect of a higher rate of interest.

COVERED ARBITRAGE

What happens normally? Lenders who wish to place funds in another country, and therefore in another currency, can ensure themselves against the attendant exchange risks not only by buying the relevant foreign currency for immediate delivery, but also by selling that foreign currency on the forward market at the same time. Provided the cost of this insurance (namely, the difference between the spot and the forward rate) does not exceed the extra interest that can be earned, the lender would proceed with the investment "on a covered basis"; that is, he would buy spot and sell forward the foreign currency at the same time as fixing the lending in foreign currency.

The theory of interest arbitrage states that this cannot happen. Practice shows that it does. This apparent contradiction may best be explained by a comparison with the world of physics.

If two tanks containing water are connected by a pipe at their lowest point and if this pipe is of sufficient diameter and kept clear, its presence will make possible the flow of water from one tank to the other and will ensure that the water in both tanks is

always at the same level, although this level will vary every time water is taken from or added to the system. It does not matter in which section of the system alterations are made; whichever tank is affected, a balancing effect will be transferred to the other. It is thus true to say that equilibrium is ensured, making the two water levels identical, and that this must always be so. It is also true, however, that water will move in one or the other direction through the pipe whenever an addition or removal of water from one tank has temporarily made the water levels unequal; the movement of water through the pipe is a precondition of the normal equilibrium of water levels (when there is no movement through the pipe) and not, in fact, a contradiction of it.

In the case of money, the following comments similarly apply:

- The theory of interest arbitrage confirms that forward cover can make overseas short-term investment immune from exchange risks.
- Forward deals will be done in simple response to interest rate impulses whenever the interest rate gain is more than the cost of forward cover.
- 3. Money will move immediately and in large amounts whenever this is true.
- 4. This possibility of moving short-term funds from one center to another guarantees that rate advantages will be fully utilized at once, and will stop being used only when the movement has affected demand and supply for the money, or for the foreign currency involved, to such an extent that the rate ceases to be attractive.
- There is a mechanism here for establishing and maintaining equilibrium, akin to the physical mechanism of the connected water tanks.
- Only minor advantages can exist, and very minor gains can be expected, from moving funds on a covered basis.

Money Across Frontiers

7. The return on lending funds to borrowers of similar standing in any major currency, after taking into account the cost or benefit of forward cover, must be identical.

PRACTICE VERSUS THEORY

All this is true, and yet funds move. There are two causes for this.

- 1. The "water pipe," so to speak, may be too small to take the traffic, and adjustment may be delayed; often a change in rates is so sudden and so large that the new equilibrium can be reached only after a considerable movement of funds. Such redeployment of money tends to cause liquidity problems and meets with resistance from the institutions involved, so that a delay occurs.
- 2. It is also possible for the "water pipe" to be clogged up with "dirt" to inhibit the free flow of water; many countries limit the allowed movement of short-term funds out of their own money market into foreign money markets or vice versa. This too will delay the otherwise automatic process of reestablishing equilibrium.

Even if neither of these delaying factors operated there would still be money moving in large amounts across frontiers. The reason for this is that professional managers of money must seek optimum returns for their cash and will therefore regard even an extra ½2 percent per annum for a few weeks on a large amount of money as worth having. Such slight differences may arise because a special demand for money in a particular currency, or for a forward deal with a specific commercial background, puts a slight temporary pressure on one currency. Often these circumstances are known to only one bank and it will therefore enable that bank to improve the return on its own or its customers' money on that particular day.

It is thus true that, as with the water tanks, two apparently contradictory statements are both valid. Interest arbitrage assures us of a situation of equilibrium and normally eliminates the chance of profit from moving money abroad without incurring an exchange risk. However, some such movement, obviously in response to the profit motive, does take place: it is this which makes the achievement and maintenance of equilibrium possible. In the case of the water tanks, the water levels are always equal, but only because water keeps flowing through the pipe whenever levels become unequal. In the case of money, the theory of interest arbitrage ensures a static location of funds which are to be invested without exchange risk, but only because funds do move as soon as this static situation is disturbed.

HOT MONEY

Once the theory of interest arbitrage is accepted as true and confirmed by the actual relationship of interest rates and forward exchange rates from day to day, its various and far-reaching consequences become apparent. Two of these need to be mentioned.

Changes in discount rate or in other government-controlled interest rates, decided upon not for reasons to do with domestic credit but because it is desired to alter the currency reserves by a change in the flow of inward or outward short-term investments, are effective only in so far as those who control funds are undisturbed by exchange risks and do not cover forward. For all others, the interest arbitrage calculation is relevant and the actual level of interest rates (taken by itself) is not.

It has already been suggested that, when placing funds, fewer and fewer professional managers of money look only to interest rates and completely ignore the risks inherent in an open position in foreign currency. That some still take this kind of risk is evident from responses to recent changes in interest rates, but it is not possible to assert simply that funds come in when rates are raised and go out again when they are lowered. Sometimes even the reverse happens.

We must, therefore, accept that the use of interest arbitrage by so many professional managers of money makes it imperative for governments to find some way, other than merely by increasing domestic interest rates, to attract foreign funds if they wish to bolster reserves. Governments often wish to do this, although they are inclined to scoff at the result of their deeds by calling money thus attracted "hot money," the adjective having a negative sense in this connection. No doubt it is the fickleness of such funds rather than their existence which is deplored.

There are three main ways of attracting and keeping short-term funds, apart from the old-fashioned and often ineffective way of paying "over the odds" for them. The first, most obvious, and best way, but also the hardest, is to organize the domestic economy in such a manner that funds are brought in on a sustained wave of confidence. The growth of such an economy ensures good dividends; the resulting stability of the currency, although probably resulting in low returns on fixed interest deposits, still attracts them because of the absence of devaluation fears and the presence of revaluation hopes. This state of affairs is within the reach of any industrialized country, whose citizens should have normal good sense and a healthy political and social attitude.

The second way to attract funds or prevent their departure is by exchange control. This is, at worst, a locking of doors where the wish to cross thresholds does exist. At best, it is an adequate way of coping with a nation's persistent failure to provide the social climate and economic growth which ought to be achieved to make such restrictive measures unnecessary. Some countries prevent the departure of foreign-owned funds by restricting the homeward remittance of dividends or the borrowing of local currency by foreign-owned subsidiaries. Others merely restrict the outward movement of resident-controlled monies. Any of these steps eases the task of keeping the country's reserves of foreign exchange undiminished.

The third way is subtler, less permanent, and also less damaging to long-term industrial planning than exchange control. It involves intervention by the central bank in forward exchange

rates. By this step the difference between spot and forward rates, and therefore the cost of forward cover, can be amended and the interest arbitrage calculation kept artificially out of equilibrium. It is as if an official continuously poured water into one of our two water tanks because it has been decided to power a government mill with the resultant flow of water. It can be done and it has been done. The only snag is that no central bank can go on giving or taking foreign currency in large amounts forever; eventually the day of reckoning will come and the need to reverse the deals will aggravate the situation unless underlying conditions, such as the trade balance or confidence in the currency, have changed meanwhile.

THE MEANING AND SIGNIFICANCE OF FORWARD RATES

The other important consequence of the interest arbitrage doctrine is that, because it teaches us that forward rates affect interest rates and interest rates affect forward rates, we can no longer allege that the forward premium or discount of a currency accurately reflects the faith or lack of faith people have in that currency. Such faith, of course, may find expression in the forward rate and there are many examples to confirm this. It is. however, a far less reliable indicator of the extent of such feeling among operators (including commercial customers as well as bankers and speculators) than is often supposed. Only if interest rates for at least one of the two currencies are completely flexible and uncontrolled by the authorities or by liquidity considerations can sentiment affecting the currency relationship be fully and accurately reflected via interest rates in the forward premium or discount. As soon as interest rates are affected by other influences it must follow that the forward premium or discount cannot fully express sentiment about future currency values.

There are many illustrations to substantiate this point, the best known of which perhaps is the growth of the discount for the pound sterling immediately after its devaluation in 1967. At that

Money Across Frontiers

time the risk of a further devaluation was minimal so soon after the first, yet the insurance against this eventuality had doubled in cost. The reason was a 2 percent increase in bank rate. Only the doctrine of interest arbitrage can explain this.

INTEREST ARBITRAGE AND BUSINESS TRANSACTIONS

This, then, is the meaning of interest arbitrage for the importer or exporter: that forward rates do not necessarily, and rarely accurately, reflect the risks involved.

Because the forward cover, unlike any other insurance cost, has no actuarial relationship to the risks, the businessprofessional must ponder two separate sets of questions when deciding whether to insure against the exchange risks of any particular international deal.

- 1. He must first consider whether to cover the currency forward immediately after signing the commercial contract or to cover the currency spot when the time of payment comes, or even to stay uncovered temporarily and review the situation once a week or once a month. Thus he must decide whether he wishes to carry the exchange risks uninsured, which will depend on his estimate of the currency situation and also on the financial importance to his company of any loss that might result.
- 2. If he estimates the risks to be great and the possible losses to be crippling for his business, he will have to proceed to the second set of questions. These concern the cost of cover. This cost, as we have seen, may be greater or less than the insurance premium he would deem appropriate. A 50/50 chance of a 10 percent change in the rate might justify an insurance cost of up to 5 percent, but in foreign exchange it could work out at 2 percent or at 12 percent.

In the latter case the businessman must accept the inevitable and remain uninsured, regretting his earlier commercial contract, and rely on prayer and hope. In the former case he will insure by covering forward, grateful that money market forces (whether natural or government induced) have caused an interest arbitrage situation that keeps the forward rates below the level they might have reached if opinions about future exchange rates were alone responsible for the cost of forward cover.

The doctrine of interest arbitrage therefore adds a burden of thought and decision to the life of the sophisticated business-professional engaged in international trade of any kind. Not only must be decide for himself, in the particular situation of the moment both whether cover is necessary and whether the cost of cover is appropriate. He must also know that sometimes forward cover is cheaper than the likely cost of covering spot at a later time, so that he might enter the forward market not only to reduce risks but also to increase profits.

His earlier decision whether to invoice or to be invoiced in his own currency or in a foreign currency will likewise depend on what he is likely to do about forward cover if he has chosen foreign currency invoicing.

Summary

The interrelationship of the money market and the foreign exchange market, too often ignored and too little understood, and contained in the doctrine of interest arbitrage, creates problems and poses difficult questions for the business executive. At the same time it opens to him a field of opportunity and profitability. To ignore this is like manufacturing without accountancy or selling without advertising. Forward covering has its problems, but it can be a source of real opportunity.

The following is an actual example that illustrates the principles discussed in this chapter.

Money Across Frontiers

Example:

1. The pound spot and forward:

Spot 1.5850-1.5855*

Forward sterling at a discount against dollars:

1.90-2.00 for three months.*

2. Eurocurrency interest rates:

3 months sterling 14-14¹% per annum.*

3 months dollars 9-91% per annum.*

Therefore:

3. Does it pay to turn sterling into dollars and deposit as dollars?

Cost (loss of sterling earnings) 14% Gain on swap $4\frac{3}{4}\%$ Interest offered for U.S. dollars 9%

The U.S. dollar deposit is $\frac{1}{4}$ percent per annum less attractive than the sterling deposit.

4. Does it pay to turn dollars into sterling and deposit as sterling?

Cost (loss of dollar earnings)

Cost of swap

Interest offered for sterling

9%

5%

14%

The sterling deposit is no more attractive than the dollar deposit. This equilibrium position is largely due to the dealing costs incurred when money is moved and currencies have to be traded both for spot and for forward delivery. Telephone expenses, brokerage, the cost of confirmations and of payment orders, and the value of employees' time must also be taken into account.

5. Method of calculation of swap:

- a. For 3: 1.90 cents (discount offered) multiplied by 4 (to turn 3 months into 12 months) and then divided by the number of dollars obtainable per pound for spot delivery, viz. 1.5850.
- b. For 4: 2.00 cents (discount charged) multiplied by 4 (to turn 3 months into 12 months) and then divided by the number of dollars spent to obtain pounds for spot delivery, viz. 1.5855.

Chapter 4

6. How to check these calculations:

1% of \$1.5850 per pound is $1.58\frac{1}{2}$ cents or $158\frac{1}{2}$ points. 1.90×4 is 760 points. 2.00×4 is 800 points. If $158\frac{1}{2}$ is 1% then 760 and 800 are about 5 times this amount, that is, 5% or just under.

^{*} See the foreign exchange report in one of the daily papers.

CHAPTER 5

Bretton Woods and After

Two ideas were first discussed in the seventeenth century, but not seriously debated and thought about until about 100 years ago. One was that countries should advise one another on financial matters generally and on the financial problems caused by natural catastrophies and wars in particular. The other was that surplus countries should temporarily lend money to deficit countries. Action, however, was not taken until 60 years ago.

In 1930 the Bank for International Settlements (the BIS) was established in Basle, Switzerland. It assisted newly independent countries in the establishment of financial institutions and practices and it provided some monetary help when balance-of-payments difficulties placed a strain on the currency reserves of small nations. Within its limitations it did a good job.

Representatives of some of the World War II allies, mainly from the United States, France, and Great Britain, met at Bretton Woods in July 1944 to build new institutions. They were intended to meet three major criticisms of the prewar system: too little money available to deal with balance-of-payments problems, no authority to enforce the advise given to governments by the central international institution, and frequent recourse to floating exchange rates.

The International Monetary Fund (IMF) was to have both more authority and more money than the Bank for International Settlements at Basle. This had been the first truly international monetary institution and had operated with a considerable measure of success during the interwar period.

The IMF was set up to give aid to countries which, because of long-term changes or because of some temporary difficulty in the domestic economic scene, were short of foreign currency reserves. An elaborate system of rights and duties was designed. Funds were made available from the member countries sufficient to deal with most foreseeable situations of this kind. As the years passed, these funds have been increased substantially and indeed have proved to be generally sufficient as various international currency crises developed.

The problem of endowing the central organization with a necessary measure of authority was more difficult and undoubtedly was only partially resolved. Certain undertakings have to be made by countries when borrowing from the IMF, but it is arguable that these undertakings are not of a very definite kind, and that very little can be done by the IMF if they are not honored. The letters of intent which have so often been discussed in the past are part of this machinery of compulsion. They are formal undertakings by sovereign states to take definite measures to correct adverse trends in the domestic economy when borrowing from the IMF exceeds certain limits in size or duration.

INTERVENTION POINTS

The key to the system devised at Bretton Woods was that exchange rates should be allowed to fluctuate only within narrow

limits set by so-called intervention points. Each country, having fixed a parity against the U.S. dollar and also defined in terms of gold, was committed to allowing fluctuations only within a margin not exceeding 1 percent on either side of that parity, and then to intervene whenever it appeared that pressures in the market would push the exchange rate outside that bracket. In December 1971 this margin was increased to $2\frac{1}{4}$ percent.

For most countries, the 1 percent margin had been sufficiently wide to allow for normal fluctuations due to seasonal conditions and temporary changes in the domestic economic situation. For a few, such as Canada, it tended to be too small to take account of the pressures on the demand and supply of foreign currency that occur from either commercial or investment causes. Therefore, there was considerable discussion for some years as to the desirability of widening the allowable margin for some countries or for all.

In the system of so-called fixed exchange rates it is clearly desirable to allow margins which will make pressure on the currency at either the top or the bottom intervention point fairly rare. It is arguable that the fluctuations that do normally occur in the foreign exchange market will tend to be greater if the allowed fluctuation is greater. In the absence of regular intervention at intermediate levels by the central bank, it is possible that a larger allowed margin of fluctuation results merely in larger actual fluctuations. This causes greater uncertainty to traders and investors and results in unpleasant weeks of real pressure at the intervention point, creating distress for those in charge of the national currency.

During the years following the establishment of the IMF and of the free foreign exchange markets (which had been closed for so long before, during, and after the years of war) the practice developed for central banks to intervene not only at the intervention points, when the law required them to do so, but also at interim levels, in the interests of monetary management and the stability of the national currency. Considerable collaboration developed between central banks in this practice, as described in Chapter 1. The intervention rules laid down for the European Monetary System (EMS) and the behavior patterns developed by

central banks operating under a nominally floating system of exchange rates follow the theory and the practice of the Bretton Woods era to a greater extent than is generally realized.

INTERVENTION IN THE FORWARD MARKET

Certain central banks also intervene in the forward exchange markets, a practice that has always caused considerable dispute. Some would maintain that this intervention is an essential mechanism both for steadying the foreign exchange markets and, because of the importance of the theory of interest arbitrage, for managing domestic interest rates and the flow, inward and outward, of money. While there is much to be said in favor of occasional intervention in the forward exchange market with the aim of controlling the inward or outward flow of funds and the availability of credit inside the country, the intervention sometimes practiced on a substantial scale at times of currency crises, with the aim of reducing the pressure of speculation, is more open to doubt.

Its main disadvantages are the following: First, it tends to make the task of the speculators easier by cheapening the cost if they are mistaken, without seriously reducing the profit if they are right. Second, it tends to put a considerable burden on the intervening central bank in terms of cost. Admittedly, if the speculation is unjustified, there is profit for the central bank in this operation, but if the speculation turns out to be justified and the calamity which people expect actually occurs, then it is at the expense of the central bank that the speculators reap their profits. Consequently, the view is often taken by central banks (with a degree of modesty which may be only partially based on fact) that they ought not to act as if they are sure of the stability of their own currency when the whole world seems to be of a different opinion. In confirmation of this view one can point to the substantial intervention by the British authorities before the 1967 devaluation in the forward exchange market which added greatly to the loss the Bank of England incurred as a result of that devaluation.

INTERVENTION IN THE SPOT MARKET

Intervention by central banks for spot delivery at times of fluctuations and of general commercial pressures has become an established practice. This clearly serves a useful purpose, although many dealers in the foreign exchange market are disturbed at the unexpected timing of such intervention and the difficulty which it tends to create in forecasting developments in exchange rates.

If the role of foreign exchange dealers in making and keeping a healthy market for the benefit of the commercial and investing community is a real one, then anything that makes their task more difficult or more risky has to be considered with extreme caution. Apart from this, intervention by the central banks in the market for immediate or spot delivery is useful.

The basis for such intervention lies in a simple fact. When a change in the relationship of demand and supply for any foreign currency puts pressure on the exchange rate, the rate will change. This is the case unless some central authority removes the surplus supply or satisfies the excess demand by intervening and putting into the market some of the foreign currency in its own stock (currency reserves) or by taking the excess supply of such currency into its stock. At the intervention points, in a fixed-rate system, the central bank has no choice but to take currency into its stock or give currency from its stock. At all interim levels, however, and when floating rates are in operation, it has a choice either to do this or to let the change in the demand-supply relationship cause a movement in the exchange rate.

A government and its central bank must consider whether a growth in the reserves is more important than a splendid rate of exchange, or vice versa, and whether at times of pressure it is better to let the reserves drop or to let the exchange rate drift downward. It is this decision that determines whether the central bank intervenes in the market.

There are moments of course when central banks intervene in the foreign exchange market for much less official reasons: either to carry through an operation on behalf of a government department, or simply to test the market (see Chapter 1). The function performed by the exchange dealers of central banks in understanding and guiding the foreign exchange markets is one that must not be underestimated. It is a field in which the central banks have had a most beneficial effect on the exchange markets, and one which dealers have reason to know and value.

THE BRETTON WOODS PHILOSOPHY AND ITS EFFECTS

The system of Bretton Woods, designed in 1944, proved beneficial to the growth of economic prosperity in the Western world. It was based on fixed parities and relatively narrow dealing margins, guarded on either side by an intervention point, with substantial aid available to member countries from central funds against relatively limited undertakings to put matters right as soon as possible. This was coupled with the general philosophy that changes in parity should not be delayed if they were justified, but should not be made every time the economic situation at home required adjustment or further control. It also made possible substantial aid to less developed countries from richer and more successful nations.

Nevertheless, both the continuing plight of the Third World and the outbreak of sometimes severe and almost crippling international currency crises in the Western world have inflamed discussion as to the merits and defects of so rigid a system, as embodied in the IMF and its sister organizations. Many of the criticisms of the Bretton Woods system ought to have been addressed to the member countries rather than to the IMF itself.

The main criticism has centered on the relative rigidity of the Bretton Woods system, because, whenever a crisis broke out, the focal point of the struggle for maintaining the parity was the intervention point. It was only natural to question the very existence of such intervention points and to advocate a system either devoid of intervention points or having a greater possibility of moving them when pressure builds up.
THE CHANGE TO FLOATING

If there are no parities fixed between the currencies of the world, then rates can float freely; at no particular point is the central bank obliged to interfere. Few people seriously advocate that central banks should not be allowed to intervene in the foreign exchange markets: the social consequences of a decline or improvement in the exchange rate, together with its effect on the prices of imports and exports, are matters of governmental concern in a modern community.

There are, however, many who prefer the choice of those points to be taken on an adhoc basis by the government of the country and not fixed for years ahead. With such an arrangement, the rate is allowed to move or not, as the government sees fit. While this is an attractive idea in principle, the problems attendant upon it are such that the IMF and its main members resolutely declined to contemplate it until the 1970s.

In 1971 the United States, Germany, Holland, the United Kingdom, Japan, and many other countries resorted temporarily to floating exchange rates. The Smithsonian Settlement in December of that year brought the world back to the system of fixed parities, albeit in a slightly amended form. After the second devaluation of the U.S. dollar in 1973, floating rates were again adopted by many countries. The 1978 amendments to the Statutes of the International Monetary Fund accepted and permitted this practice which many countries continue to use. Some of them now regard it as good in itself. Many more accept it as a second-best, made unavoidable because domestic economic upheavals and violent changes in world commodity prices (oil above all) make the system of more permanently fixed parities impossible to operate.

CRAWLING PEGS

Before managed floating became common in the 1970s, academics sought a system which would give a measure of certainty to those who needed fixed rates to enable them to plan their

future activities and yet provide that system with a mechanism for change to add some flexibility to it.

For years many commentators on world currency problems had taken the view that the system of fixed parities and intervention points contributed greatly to the peaceful development of international trade, but that greater flexibility ought to be achieved. One suggestion was that when a currency is under pressure (in either direction) the intervention points could be moved a small way in the appropriate direction at the end of an accounting period of three or six months. This concept of slow devaluation or revaluation became known as the *crawling peg system*.

Some people are in favor of automatic adjustment at the end of the accounting period—the so-called mandatory crawling peg. Others would rather leave it up to the government whether or not to make use of this facility—the system known as the voluntary crawling peg. Of both these systems one can say that they cause considerable confusion and a great deal of work without solving any real problems. If the pressure on a currency is really great enough to cause concern, then a ½ percent or 1 percent adjustment of its exchange rate does not serve any useful purpose. If there are rumors circulating that a devaluation or revaluation in the order of 5 percent, 10 percent, or 15 percent is needed and if such a correction is in fact being considered seriously, then the rate adjustments permitted by the crawling peg system do little to restore confidence.

Nevertheless, many variants of the crawling peg idea have been tried, and in some cases they have functioned satisfactorily. At one time New Zealand operated a type of crawling peg. The periodic adjustments in the European Monetary System follow a similar pattern, although less formally.

NEW THINKING

The Bretton Woods system was developed with considerable skill and expertise by the leading financial experts of the world. It lived up to the demands of a quarter of a century and had been an

Bretton Woods and After

effective weapon in the struggle for prosperity. However, in the past two decades changes were forced on the system by economic crises, energy supply problems, and the new status of the dollar.

If not everything hoped for had actually been achieved between 1945 and 1971, this was not the system's fault. The achievement of international monetary stability and economic growth did, however, call for further developments, new institutions, and an open mind on the part of the member countries.

After some years of disruptive foreign exchange crises and discussions at top international level (such as the Morse Committee of the Group of Twenty or the monthly meetings of governors of central banks at Basle), the Statutes of the International Monetary Fund were amended on April 1, 1978. The most important change made in 1978 permitted floating of currencies. This leaves individual member countries free to decide whether to equip their currencies with fixed or floating parities and also how to define the relationship of their currencies to those of other countries.

In theory members of the IMF still accept that fixed rates of exchange are the ideal pattern, but that economic realities now often make it impossible to stay within the narrow limits imposed by the consequent intervention points. A regime of managed floating may at times prove less of an evil than the trauma of frequent devaluations or revaluations. These certainly upset trade and investment in the stormy years before floating began.

Nevertheless one hopes that even the countries which have adopted flexible rates will increasingly follow three basic rules:

- 1. Their exchange rate policies should be publicly known.
- Central bank intervention in the exchange markets is permissible and often necessary.
- It is useful to tie each currency to a currency basket based on the country's trading relationships.

BASKET CURRENCIES

The term "basket currency" describes a concept in the definition of national currencies that is useful, but difficult to understand. A basket of currencies (basket currency) is a unit of account. Its purpose is to provide a *numeraire* or index with which particular national currencies can be compared or against which changes in their value can be judged. More than a quarter of the world's currencies are pegged against a basket of currencies. The Special Drawing Right, consisting of known percentages of five major currencies (U.S. dollar, sterling, French franc, deutsche mark, and yen), provides such a numeraire or index.

Another use of the basket idea is the daily exchange rate for dollars or sterling, quoted in newspapers and described as the trade-weighted index. If it stands at 90.5 percent, this means that the currency is now worth 90.5 percent of what it was worth on average in the reference year in the past (which is taken as 100). Rates for many currencies are included, in proportions appropriate to their share in the country's trade in a known year in the past. The statistical data for this are obtained from the Multi-lateral Exchange Rate Model of the IMF.

When the underlying data change, this index, like any other, becomes inaccurate. A new index then needs to be introduced, but this tends to mislead simply because it uses different ingredients. Let this be illustrated by a historic example:

Until February 1981, the sterling basket used December 18, 1971, the day of the Smithsonian Settlement, as the base date with the value 100. Currencies were included in the basket in proportions appropriate to the United Kingdom's foreign trade in 1972. The dollar accounted for 32.8 percent of the total.

In February 1981 the base date was changed to 1975, the foreign trade proportions for 1977 replaced those of 1972, and the dollar's share was reduced to 24.6 percent.

It is clear that the 1981 change in this index invalidated comparisons. The new figure of about 100 percent in place of the pre-February figure of about 80 percent looked at first sight like a substantial improvement in the trade-weighted value of the pound when in fact its value had not changed. What had changed, in fact, was the comparison: previously the present rate was compared with the strong pound of 1971, and now it was being compared with the weak pound of 1975!

The European Currency Unit (ECU) is also a basket currency. It includes the currencies of the member countries of the European Community and is used extensively in the operation of the European Monetary System. Each currency accounts for an unchanging proportion of the ECU so that a change in the exchange rate of only one currency affects the international value of the ECU, but changes to different currencies included in the basket, if in opposite directions and depending on their "weight" within the basket, can cancel out. The parity grid of cross-rates and the early warning system based on the "divergence indicator" are seen in terms of ECUs.

THE BASLE AGREEMENTS OF JULY AND SEPTEMBER 1968

When the British Empire was succeeded by the Commonwealth and the arrangement became progressively looser politically, the central administration of reserves ceased to have any real force. In so far as sterling area countries still kept their reserves in London, they did so under the set of guarantees known as the Basle agreements.

The basic concept of these agreements was that member countries were entitled to diversify their reserves, that is, to convert them into a nonsterling-area currency whenever they wished, and further that some of the remainder of the balances held by them was guaranteed by British government against any loss arising from a devaluation of the pound sterling. This guarantee by the British government was made possible by an undertaking on the part of 12 countries outside the sterling area to replace the sterling held by Commonwealth countries by their own increased holdings of that currency, should the countries of the sterling area at any point reduce their total holdings of sterling. In fact, such a guarantee had the effect of causing the sterling area countries not to reduce but to increase their holdings of sterling, which earned them a high rate of interest without any exchange risk. It does mean, however, that the concept of the sterling area as a true currency area ceased to have any real meaning.

Chapter 5

The new arrangement between the 12 countries was not dissimilar to the operation of SDRs on a worldwide basis: Guarantees by the many to cushion the pressures temporarily exerted on the few.

Summary

There are three aspects of basket currencies and tradeweighted indexes which concern us all.

- 1. They are difficult to understand.
- 2. Basket currencies give a more accurate picture of the changes that occur than the old-fashioned comparison of the national currency with the currency of only one trading partner, for example, the sterling/dollar rate alone, or the dollar/deutsche mark rate alone. In other fields we already accept this: a retail price index is more likely to tell us the true rate of inflation than the comparison of this year's price of one commodity, however widely consumed, with last year's price.
- 3. As already noted, changes in the base data invalidate comparisons. Using increasingly out-of-date base data also invalidates comparisons. This problem of the statistician is inevitable.

CHAPTER 6

Currency Areas and Currency Reserves

There are in practice a number of currencies which act as a focus or pivot for a group of other currencies. This situation can be the result of political centralization, as in the case of the sterling area in the days before World War II or more recently with the Soviet ruble. In other cases some currencies become the decisive leaders largely because most of the international trade in their part of the world is invoiced and paid in those currencies; this applies to the dollar and the German mark. Usually such currencies are held by governments, as well as industrial and commercial companies, prior to payment, as a reserve; thus they function as reserve currencies. This in turn adds to their strength and importance, and increases their usefulness for trading, lending, and investment purposes.

THE OLD-FASHIONED CONCEPT OF A CURRENCY AREA

The sterling area was a currency area. The members of it kept their reserves in the currency of the area; they paid all foreign currency earnings into the currency reserves of the central country and in turn drew on those reserves for their foreign currency requirements. With the notable exception of Canada, it included most of the countries of the old British Empire, the present Commonwealth nations, and also one or two other countries. The United States is still such a currency area and for a long time the sterling area was of a similar kind.

This type of currency area presupposes a certain amount of political unity or at least a measure of central political control. It means that the political entities within it who earn a great deal of foreign currency are willing to allow those who earn a great deal less to spend some of it.

A second meaning was added to the sterling area as a result of World War II when exchange control was introduced. Under the Exchange Control Act 1947, which succeeded the wartime measures, payments from the United Kingdom to countries in the sterling area were not subject to exchange control, and therefore investments in those countries were entirely free. Exchange control affected payments by members of the sterling area to those outside it and the maintenance of assets outside the sterling area by residents of the sterling area. It did not interfere with payments within that area.

THE NEWER CONCEPT OF A CURRENCY AREA

When the British Empire was succeeded by the Common-wealth and the arrangement became progressively looser politically, the central administration of reserves ceased to have any real force. In so far as sterling area countries still kept their reserves in London, they did so under the set of 1968 guarantees known as the Basle agreements. These promised to indemnify

Commonwealth countries against losses incurred by them through a possible devaluation of sterling. Thus the sterling area ceased to be a currency area in the strict sense, although the pound kept some of its international functions as a trading currency and continued to be used by some of its major trading partners as a reserve currency.

The sterling area ceased to be a single exchange control area in 1972, thus destroying another essential aspect of a currency area in the old-fashioned sense. From 1972 until the abolition of exchange control in 1979, the U.K. restrictions on overseas payments and investments drew the circle of protection only around the British Isles and no longer around most of the worldwide British Commonwealth.

MAJOR CURRENCIES' ZONES OF INFLUENCE

The most used currencies of the world, in particular the U.S. dollar and the German mark, acquire a significance beyond their normal use for trade between their country of issue and its trading partners.

- They, and not the currency of the other country, are used for trade payments and for borrowing transactions for two reasons:
 - a. Citizens of the larger country can usually determine in which currency invoices shall be written or debts expressed. They tend to choose their own currency, thus leaving the other partner to worry about the exchange risk or to insure against it.
 - b. The more a currency is used, the easier it is to trade it, to cover forward in it, to borrow and lend it, to gain information about it, and to make accurate forecasts concerning it.
- 2. People in smaller countries find that it is wise to denominate business, even between them and those in other

small countries, in dollars or marks. This is so because of the reasons listed in 1b above and also because of the many trade connections with the major currencies which are of effective significance in pricing procedures in a competitive world market.

The result of this linking up of smaller currencies with the giant currency of the same zone of influence can be put simply thus:

- 1. It pays smaller countries to tie their currencies (formally as in the European Monetary System, or more pragmatically as in the case of the Canadian dollar, the British pound, or the Swiss franc) to the nearby giant. This reduces frequent and often erratic fluctuations in the exchange rate. Such fluctuations do help speculators but greatly endanger the business of genuine traders, manufacturers, and investors.
- 2. The link between the smaller currency and its local giant, whether formal or merely pragmatic, reduces speculative attacks on it and uncertainties arising from likely developments of an economic kind. This, in turn, gives stability to the exchange rate because of the tie-up, which far exceeds the normal exchange rate stability of a small currency.

RESERVE CURRENCIES

There is a further advantage of a close tie-up with a major currency: such a major currency is likely to be used as a reserve currency. The affiliation with its smaller neighbors further increases such use. The effect of this reserve function is that the major currency can be held freely, invested profitably, and traded easily. Indeed, one of the definitions of reserve currency is a currency that can be held freely, invested easily and profitably (both short-term and longer-term), and traded easily (both spot and forward) in most financial centers.

Currency Areas and Currency Reserves

It is, however, wise to remember that all definitions of what makes a currency a reserve currency are strictly speaking not definitions but descriptions. There is no set of characteristics admitting currencies to the club of reserve currencies. Worse still, no government can decide that its currency shall or shall not be a reserve currency.

In the end a reserve currency is a currency in which many governments and many corporate industrial or financial entities choose to keep their reserves or spare funds. Safety, flexibility, freedom, and profitability are among the criteria which affect the choice. The holder of money makes that choice. He, with his fellow executives, appoints a currency to the rank of reserve currency. The government which issues that currency has little to say in the matter. The viewpoint of the Bank of England or the Deutsche Bundesbank on the desirability or undesirability of its currency's use as a reserve currency has had negligible influence on its actual use for this purpose in the past.

Is It Good to Be a Reserve Currency?

To have the national currency used as an international reserve currency has advantages and disadvantages. It provides a volume of foreign-owned monetary assets to supplement domestic resources and supports the country's financial institutions and economic activities. This is particularly true when the currency is the world's lead currency (as the dollar currently is) or when the reserve function is part of fixed arrangements within certain territories (such as the sterling area or the French franc area used to provide).

If a country's currency is used as one of the reserve currencies, the government and the central bank of that country have an obligation to see that the obvious advantages are not outweighed by the disadvantages. This requires vigilance, a sense for good public relations in the monetary field, and special attention to the control of the money supply and the development of the rate of exchange.

The disadvantages consist mainly in the volatility of funds, which is most strongly felt and rightly feared when the currency is weak and there are no political ties or exchange control type restrictions to restrict the movement of currency reserves from one home to another.

At various times the currencies not only of the United States, Great Britain, and Germany, but also of France, Japan, Switzerland, and others have been used as reserve currencies. It is probable that the resulting problems are more likely to be bothersome when a relatively small country finds its currency used extensively as a reserve currency by nonresidents whom it cannot easily control. Attempts by Switzerland, for instance, to prevent nonresidents from holding Swiss francs have been troublesome and largely ineffective.

The Mystique of the Lead Reserve Currency

The criteria which we might apply in balancing the advantages and disadvantages of being a reserve currency are quite different when we look not at the second, third, or fourth reserve currency of the contemporary world but at its first or lead reserve currency.

For most of the time since World War II the U.S. dollar has been the first, or lead, reserve currency. Gold no longer provides a sensible alternative. Other currencies, however likely to keep their value, don't usually offer the flexibility, accessibility, multiplicity of outlets, and size of market to make them equally attractive for any length of time.

The first or lead reserve currency is in a position which no other currency enjoys. The greater the deficit in the country's balance of trade, the more the amount of its currency foreigners will hold and will bank in its financial institutions.

Put differently, if you spend more than you earn you will eventually run out of money and go bankrupt. If, however, you are also the banker in whose bank the recipient of your payments deposits all the money, you will not go bankrupt. As banker you receive what as trader you overspend.

Currency Areas and Currency Reserves

This is how the lead reserve currency functions. Therefore the large deficit in the U.S. balance of trade has no deleterious effects unless:

- People think that overspending is bad in itself because it enables others to sell to the United States more than the United States can really afford to buy; or
- 2. Those who receive dollars for their goods and services have decided, or are deemed likely to decide in the near future, to keep some of those which they don't immediately need (and therefore wish to keep "in reserve" for future spending), not in U.S. dollars but in marks, yen, francs, or pounds.

CHAPTER 7

The European Currency

The long-term aims of the European community, as laid down in the Treaty of Rome in 1957, envisaged a growing similarity of economic standards and social conditions throughout Europe. This would eventually lead to exchange rates which, because economic conditions were no longer allowed to diverge, would not need to change one against the other. Alternatively, a single currency could then replace the separate currencies of Europe.

The much-publicized plans for a free internal market starting in 1992 include the removal of restrictions on all payments from one European country to another; this would both facilitate and necessitate the unification of European currencies in due course.

THE WERNER PLAN

Therefore it is not astonishing that, when in 1971 the governments of the then six Common Market countries (France, Italy, West Germany, Belgium, Luxembourg, and the Netherlands) made their reactions to the Werner Plan known, it became clear that the notion of a joint currency had to be taken seriously. The Plan was accepted.

The Werner Plan proposed increased cooperation between the central banks of the Common Market countries. In the initial years, the fluctuations between their currencies were to be reduced by a common policy of intervention in the foreign exchange market (the snake in the tunnel).

Later—the Werner Plan said 1980—the currencies of the member countries would be permanently and irrevocably tied to the existing exchange rates, then to remain unchanged forever. This would mean neither fluctuations of exchange rates nor changes in parities thereafter.

To historians in the twenty-second century this will probably seem no more surprising than the unification of the Scottish and English currencies or the use of identical dollars throughout the United States. To us in the twentieth century such a change seems revolutionary, because we are conscious that sovereign states of considerable age and diverse history are still pursuing separate and even divergent economic policies. As long as they wish to do so, a joint and unified currency is impossible.

Tying together the European currencies will mean that no member of the European Community could devalue or revalue. This will give rise to two problems which merit careful consideration.

First, if no more exchange rate adjustments are possible, the agreement being irrevocable, then a few changes in parities will have to take place in the year before it becomes effective. Such changes would not be based just on past experience and the foreseeable future but also on a vague and uncertain assessment of longer-term economic, social, and political developments.

Second, once the currencies are irrevocably tied to an existing exchange rate, devaluations and revaluations cease to be available as a remedy for economic difficulties. If, in addition, it is no longer allowed to use exchange control in normal times, the remaining possibilities for influencing the economic situation are all in the area of domestic economic and social policy. Deflationary measures will sooner or later be inevitable. The population suffering from a high inflation rate will have to accept unemployment without unemployment benefits, or high taxation, or a wages and prices policy, or a credit squeeze and high interest rates. If it does not do so, the other members of the Community will have to support the ailing country indefinitely: foreign currency will have to be lent from a central fund to finance the country's excess spending. To idealists this may seem the ultimate in international charity, but it conjures up alarming possibilities in a world where political democracy and the freedom of pressure groups to campaign for better conditions are both realities and sacred principles.

A short look at exchange rate fluctuations for the German mark, the pound or the French franc in the last 20 years suffices to illustrate the extent and duration of international aid which would have been needed if exchange rate adjustments had not

been possible as a last resort.

If and when the new European currency becomes reality, one of the prerequisites for the establishment of a new reserve currency will have been created. This would lighten the burden on the dollar and reduce the benefits that the dollar derives from its role as lead currency. It would also mean that the European currencies might jointly carry the burden carried by sterling in the past. This may happen in 1992 or soon after.

The current reserve role of various European currencies is less important and less worrying than the immense responsibility for neighboring economies that will burden the members of the

fully developed European Common Market.

Many problems still need to be solved for the economic and social development of Europe to be steady and positive. The involvement of as many nations as possible is just as important as the continuous development of a European sense of unity and neighborly belonging-together. Foreign exchange schemes cannot bring about such a development, but they certainly can and should support it.

THE SNAKE

The nickname "the snake" given to the currency arrangements in the initial stages of the Werner Plan arose from the visual presentation of the resulting rate pattern. When some currencies were near the top of the allowed band and some near the bottom, the snake was fat; when they were all bunched close together, the snake was thin.

Between 1972 and 1976, Belgium and the Netherlands operated on a smaller margin (1½ percent) than the others (2¼ percent) and thus created a smaller snake within the snake. This was known as "the worm." The snake and the worm are shown graphically in Exhibit 7.1. In this exhibit the snake maximum is 2¼ percent, the worm maximum is 1½ percent, and the tunnel maximum is 4½ percent (2¼ percent on either side of parity).

Exhibit 7.1. The Snake

The European Currency

From 1972 until 1973 the European currencies had fixed rates against the U.S. dollar so that they could only move against the dollar within a narrow band (2½ percent either side of parity) and in unison. This gave rise to the term "the snake in the tunnel."

The snake began its life in April 1972 and died after many vicissitudes in December 1978. France, Italy, and the United Kingdom participated for only part of that time. Six other countries took part for varying periods.

THE EUROPEAN MONETARY SYSTEM

This, too, is a method for reducing short-term exchange rate movements between the participating currencies. It began operation in March 1979, as successor to the snake, and included Germany, Belgium, the Netherlands, France, Italy, Denmark, and Ireland. Spain has joined the system more recently.

A central fund, the European Monetary Cooperation Fund, facilitates the settlement of payments resulting from intervention. Allowed margins are again 2½ percent either side of parity, with an optional alternative (6 percent) available to facilitate the participation of countries liable to find their currencies under pressure. Italy made use of this concession until January 1990, and Spain still does.

Thanks partly to the determination of France and Germany to make the system work, the European Monetary System (EMS) has survived with relatively few parity changes and with its general structure intact. Between 1979 and 1987 eleven realignments took place, followed by three years of stability, after which a small change in the lira rate was necessary at the beginning of 1990.

The United Kingdom delayed its membership in the EMS. It is not difficult to see that the commitment to less flexible exchange rates, which the EMS requires, places restraints on its domestic economic policies. These would be outweighed by the assurance of more stable prices in trade with the other member countries.

However, the main objections to British membership in the EMS are probably political and, in the view of many, no longer justified.

ADVANTAGES AND DISADVANTAGES

The financial and economic consequences of belonging to a currency area are complex and can vary dramatically from month to month. For this reason membership may be beneficial at one moment and detrimental at another. A balance needs to be struck to enable one to evaluate the likely effect over a longer period.

The main economic advantages of belonging to a currency area like the European Monetary System:

- Exchange rates are predictable and the exchange risks affecting imports from and exports to partner countries are limited.
- 2. In so far as the system is seen to be taken seriously by the governments concerned and backed by sufficient resources, parity changes become both less frequent and less sudden. Speculation is less profitable and, as a result, less likely to occur and to distort seasonal and other predictable trends.
- Internal and external influences on the exchange rate are shared by the currencies of partner countries and their impact is reduced. This may be welcome.
- 4. Internal and external influences on the exchange rates of partner countries have an impact on the exchange rate of the domestic currency. This may sometimes be welcome.
- 5. By belonging to a large currency block, the effect of fluctuations in the exchange rates of nonmember currencies is shared by the country's main trading partners and joint policies to deal with them can be devised.

The European Currency

The main economic disadvantages of belonging to a currency area like the European Monetary System:

- When pressures become too great to resist, parity changes occur, and their magnitude and timing are often hard to predict precisely.
- 2. Domestic economic policies, in particular those concerning the volume and cost of credit and those which directly affect the level of employment, are partly dependent on the constraint of a fixed rate of exchange.
- 3. Internal and external influences on the exchange rate are shared by the currencies of partner countries and their impact is reduced. This may be unwelcome.
- 4. Internal and external influences on the exchange rates of partner countries have an impact on the exchange rate of the domestic currency. This may sometimes be unwelcome.
- Central bank intervention results in an increase or a reduction in the domestic money supply and has to be counteracted by open-market operations or other measures.

en de la companya de la co

CHAPTER 8

Gold

Gold has had monetary uses since time immemorial and in earlier centuries its industrial uses were closely linked to its monetary functions. Only in more recent times have these industrial uses been extended from jewelry to dentistry, electronics, and others.

THE HISTORY OF GOLD

The most recent chapter in the story of gold as a reserve medium in the contemporary world starts in January 1934 when President Franklin D. Roosevelt raised the price of monetary gold to \$35 per fine ounce. Several comparatively insignificant increases in previous months had prepared the ground for this. His motives were to cause an inflation in prices of raw materials and thus to jerk the world out of the Great Depression.

The subsequent story has been overshadowed by the motives just referred to. It was difficult to accept that a rise in the price of monetary gold is inflationary only in certain circumstances, or that the price of monetary gold need not necessarily increase when world prices do so. Those who were exasperated with the unchanging price of monetary gold—still \$35 per ounce in the 1960s—tended to point out that all other prices had doubled, trebled, or quadrupled, and used this as an argument in favor of changing the price of monetary gold too.

The price of monetary gold is commercially relevant only when governments are free to use gold to increase their overseas expenditure and have no other way of doing so. With national currencies and Special Drawing Rights now constituting at least two thirds of the world's reserves¹ (and a proportion of every country's reserves), governments are no longer dependent on changes in the price of monetary gold for their increased expenditures overseas. The cry that the price of monetary gold is unrealistic has therefore long since ceased to be meaningful. Nor were the changes to \$38 in December 1971 and to \$42.20 in February 1973 of any real significance in this particular debate. The former was primarily necessitated by the need to find a politically accept-

¹ It is difficult to state the proportions precisely. Some governments still value their gold stocks at around \$42 per ounce, others at 50 percent of the market price, others at 75 percent of the market price, some even at the actual market price (over \$400 in 1989). Valued at the former official price of \$42.20, the monetary gold reserves amount to about 5 percent of the world's total gold and currency reserves. This is too modest a figure. If, however, these reserves are valued at the free market price (say \$400) gold appears to constitute over 30 percent of the world's total gold and currency reserves. This too is unrealistic since in practice the bulk of the world's monetary gold cannot be sold, because it would swamp the market: the gold held by governments as part of the currency reserves is the equivalent of the total world production of gold over several decades.

able formula for the revaluation of certain currencies such as those of Japan and France.

THE GOLD POOL

A two-tier system operated from 1934 until 1961. It simply means that only central banks dealt with each other at the official price and that all others met in the world's markets and traded at a price reached freely by matching demand and supply. Provided international monetary discipline was effective, which it generally was, the two markets or tiers were kept apart.

The operation of a two-tier system did mean, however, that high price levels in the free markets caused doubts as to whether the official price was not "unrealistic" because it was much lower. This invariably encouraged speculative gold buying. This, in turn, raised the free market price, inconvenienced the genuine industrial users, and rocked the international monetary boat. To obviate this the Gold Pool was formed in 1961.

Eight of the countries who were large holders of monetary gold agreed to feed a central Gold Pool in London in agreed proportions. This Pool was to supply gold at \$35 per ounce to all buyers. It thus became unnecessary for industrial users or speculators to pay more than \$35 for gold; the price on the free market dropped to this level. When this had been achieved, the activities of the Gold Pool were extended in 1962 to buying as well as selling gold at \$35. As a result, the price could neither drop below \$35 an ounce nor rise above it and in effect it became pegged at \$35 for all purposes, whether monetary or commercial.

The Gold Pool's main justification was that it provided stable prices for the metal in the interests of industrial users and producers. This was even more important than in the case of other metals because of the unavoidable influence of speculative situations arising from gold's monetary use. It also made the task of the Gold Pool more difficult: demand and supply might not alter radically or suddenly from ordinary commercial causes, but the

Chapter 8

second or monetary use of gold affected people's views at times of currency crises and tended to cause disproportionately large fluctuations in total demand.

GOLD CRISES

During the months before and after the devaluation of sterling in 1967, gold hoarding reached enormous proportions. Up to \$4 billion above the normal annual figure is said to have been spent that year on buying gold for this purpose. The eight Gold Pool countries had to give the gold to satisfy this extra demand and the gold content of the reserves of some of these countries thus dwindled rapidly. Italy and Belgium were rumored to be short of gold. France disapproved of the idea of helping speculators by selling them gold on the basis of "heads you win, tails you lose nothing" and left the Pool. At that time the United States was still bound by law to hold gold to an amount equivalent to 25 percent of its note circulation and was rapidly approaching that minimum level. This rule was rescinded in March 1968.

All these facts pointed to the possibility of a change in the system. By the beginning of 1968, it was becoming apparent that the gold price would have to be raised or the one-tier Gold Pool system abandoned. The latter course was chosen on March 17, 1968. The world returned to the pre-1961 system, the two-tier system. Only governments dealing with monetary gold now had access to the U.S. Government at \$35 and even they were asked not to buy. All others operated on the free market at a price dependent on the state of the market. This was not ideal nor did it really suit the producers, but it was workable.

In August 1971 the United States formalized its unwillingness to sell gold even to central banks and terminated the link between the dollar and gold. The official price of monetary gold thus became as lacking in significance as the numerical size of a telephone number.

DEMONETIZATION IN THEORY

The abolition of the official role of gold in the monetary system thus began in 1971.

Amendments to the Articles of Agreement of the International Monetary Fund, which became effective in April 1978, had the objective of avoiding the meaningful re-establishment of a fixed price for gold. No longer do member countries subscribe to the fund partly in gold. No longer are exchange rates fixed or expressed in relationship to gold. No longer is the value of a Special Drawing Right defined in terms of gold. No longer are governments tied to an official price in their dealings with each other and in the marketplace. The official price of gold had already ceased to exist in August 1975.

DEMONETIZATION IN PRACTICE

In practice demonetization has not gone very far. It is, of course, true that a slow phasing-out of gold from its official monetary role, if not necessarily from its function as a means of private hoarding, is bound to occur over the next few decades. Already its place in official monetary reserves has been reduced to only one-half of the total and this process seems destined to continue. To hasten the disuse of gold in monetary reserves beyond this present development would serve little useful purpose and create unnecessary difficulties.

The long-term trend of prices in the free gold market may again take gold up to \$500 per ounce or beyond, which the producers would welcome in a period of rising costs of production, but this expectation is only reasonable insofar as the supply of gold and the industrial and hoarding uses of gold remain unchanged. A sudden unloading of a large part of present monetary gold stocks, released from their use as monetary reserves, would indubitably slash the free market price and ruin the gold-mining

and refining industries all over the world. For this reason, if for no other, the advocates of rapid demonetization need to be restrained. Sales of gold by the United States and by the International Monetary Fund (IMF) since the 1978 changes in policy have been fairly substantial. They did not, however, cause a collapse in the free market price of gold because they coincided with a period of naturally rising prices due to industrial and speculative demand for gold.

As gold is still important both as a reserve asset for governments and as a store of value for individuals afraid of war or inflation, its price should therefore be a matter of active concern. Might it be desirable to establish an improved variant of the Gold Pool system of the 1960s? At times of heavy speculation the unconditional commitment by the major central banks to supply cheap gold to all and sundry became embarrassing and positively harmful to monetary stability. However, it is possible to visualize a system of regular official intervention in the free gold market which would counteract upward price trends from commercial causes without having also to be operated when the market is overwhelmed by speculative demand. Such a voluntary gold pool with the right to intervene or not, as its managers thought fit, would achieve steadier markets for producers and industrial consumers and reduce the extent to which the free market price of gold might otherwise rise or fall. If the gold price tends to rise such a system would also help in the demonetization process by drawing some gold stocks from monetary reserves to the free market.

GOLD OR PAPER MONEY

The Industrial Revolution, followed by an unprecedented spread of knowledge and technological know-how, has improved the material lot of mankind. They have also increased the world's population and confronted us with new and difficult problems in many fields, not least in that of economics. Unemployment and inflation haunt us as we prepare to banish poverty, malnutrition,

and disease from the earth. We are still looking for a magical formula.

Surprisingly, some serious commentators have mistakenly suggested that the magic can be found in a return to the gold standard. This was a simple system which limited a country's ability to spend overseas to the amount which it could earn from foreigners plus its accumulated holding of gold. The gold reserves were usually rather small and not regarded as available for reckless shopping expeditions. The system thus acted as a discipline.

The gold reserves have now been replaced by larger reserves which include gold, the national currencies of other countries, and substantial credit facilities including IMF Drawing Rights, Special Drawing Rights, and central bank swaps. When cash runs short, borrowings take place. The government decides whether expenditure is necessary or avoidable, whether borrowing is sensible and constructive or irresponsible and unjustified.

The gold standard distributed reserves arbitrarily and provided a straitjacket. The more flexible reserve arrangements of the present time are related to the resources and requirements of the country in a much more realistic way. They can still seem like a straitjacket when times are difficult, but the possibility of temporary credit enables governments to face balance-of-payments problems.

The discipline is no longer in the form of an arbitrary and inflexible stock of gold. This financial decision—when and how far to live on borrowed money—now depends largely on the courage of sophisticated officeholders and ultimately on the good sense of those who vote for them. International bodies can provide general rules, give advice, and impose penalties. The decision lies where the sovereignty lies, with those whose national currency it is.

Foreign currency reserves, like the domestic money supply, must not be inflated by the printing press nor by easy credit. If they are, there must be good economic reasons, within carefully decided limits and for limited periods. The opportunities provided by the concept of paper money must be utilized with great restraint, if long-term disaster is not to follow the short-term improvement.

PROSPECTS

Ever since the days of sun worship man has held gold in high esteem. (Indeed the notion embodied in England's former system of dividing the shilling into 12 pennies is a formula harking back to the idea of one sun or gold year containing 12 moon or silver months.) As the violent story of mankind unfolded, this metal, then so rare and held therefore in almost religious esteem, became the one form of wealth which neither Biblical quotations nor hostile military action seemed able to destroy. Men stored their reserves in this form and it will take many decades yet before the last traces of this habit are lost. This is obviously less true in Anglo-Saxon countries where gold has been little held by private individuals than it is in France or the East where gold was long regarded as the best form of saving.

Modern scientific methods and new forms of international financial collaboration have provided us with adequate alternatives to gold as a reserve unit. There is, however, little evidence that mankind, especially in times of economic or political crisis, is as yet keen to substitute a different metal, a manmade substitute, or paper money (whether national money like dollars, pounds, or marks or international money like Special Drawing Rights) for the accustomed gold.

Some price trends in recent years have thrown doubt on accepted views about the free price of gold. In the past it had become normal to expect the price of gold to rise both at times of growing inflation, causing greater distrust of paper money, and at times of international tension, making people wish to hold a fairly mobile and easily recognized asset, independent of national government for its accepted value. Now, there is some evidence to suggest that this is less likely to happen.

Accurate analysis of developments affecting the free price of gold is made difficult by uncertainties concerning certain definitions. It is impossible to differentiate accurately between speculation and hoarding or between hoarding and industrial uses. When is a gold bracelet an ornament and when is it an investment?

When is a gold bust a piece of art and when is it a way of carrying a great amount of money across the world in times of war?

There is definitely a possibility that the growing costs of storage and insurance will cause gold bullion, gold coins, and golden jewelry to lose some of their attraction for hoarding purposes. Despite the political danger of nationalization, in some countries real estate is gaining in popularity as an alternative. The prices of other metals seem less volatile and more predictable precisely because their industrial uses are more important than their speculative and monetary ones. Even stocks and shares are being more widely sought as a store of value, as those in need of an inflation-proof and revolution-safe nest egg become more sophisticated and more able to operate internationally.

Changes in hoarding habits and the continuing process of actual demonetization of gold have begun to invalidate the dictum: because inflation is with us forever, the price of gold must continue to rise.

The state of the s

CHAPTER 9

World Liquidity and Special Drawing Rights

The reserves of a country are like the working capital of a company or the current account of an individual. In most countries they constitute the foreign currency balances of the central bank (some of which tend to be deposited with other central banks and some through the Eurocurrency market with commercial banks in various countries) and the gold held by the central bank, together with certain special items such as the more recently created Special Drawing Rights. As with the cash balances held by individuals or companies, so also with the gold and currency reserves of countries; it is important to remember that they do not represent the total assets of those in whose name they stand. Indeed, some of the richest countries in the world have small

foreign currency reserves, whereas some with very large foreign currency reserves have few other assets overseas. Such other assets might be in the form of stock exchange investments held by individual nationals, or subsidiaries owned by national companies in foreign countries. They also include such items as the currency balances of the commercial banks, which are of course part of the national reserve but not part of that more narrowly defined item, the currency and gold reserves.

WHAT RESERVES ARE FOR

From time to time the currency and gold reserves will be needed for purchases of food and raw materials; at other times they will be replenished from the proceeds of goods which have been sold by residents to nonresidents. There are periods in each year when countries spend money overseas which they will get back later; in the meantime they must have a fair amount of either cash or credit with which to make their purchases before the resulting earnings can be collected. It is for these purposes that reserves are held. How large these reserves need to be will depend on the type of trade of the particular country and on the type of pressures to which the country's currency is subject.

A country which imports raw materials and then earns foreign exchange, after a long period for manufacture and exportation, will need greater reserves than a purely agricultural country. A country whose currency is used for trade by other countries and in whose currency foreigners keep some of their reserves will, of course, be subject to greater fluctuations than others and will need greater currency and gold reserves.

If there was any general key to the kind of reserves which a country ought to hold as working capital it was the old view that 50 percent or more of the previous year's importation bill is an appropriate amount of reserves to be held: anything less is insufficient, anything more is adequate. Since the oil price explosions of the 1970s, however, such simple guidelines have ceased to be appropriate.

It is clear that the reserves held by most countries have not risen as fast in the last 40 years as the money value of the goods in which they trade. The problem this causes, namely a general shortage of liquidity the world over, has been discussed for a long time and in the mid-1960s resulted in a decision by the International Monetary Fund (IMF) to appoint a committee to investigate the matter. This committee was charged with finding ways to deal with the problem of the shortage of world liquidity and consisted of the Ministers of Finance of the ten most industrialized countries in the world (the United States, Canada, the United Kingdom, France, Italy, West Germany, the Netherlands, Belgium, Sweden, and Japan). Much of its work was done by a committee of the deputies of the Ministers of Finance, under the chairmanship of Dr. Otmar Emminger of Germany. The committee eventually reported its view on what should be done to increase the reserves held by various countries to make them more adequate at a time of growing international trade, and suggested the establishment of a new reserve medium which became known as Special Drawing Rights (SDRs).

HOW SPECIAL DRAWING RIGHTS ARE USED

When it was first decided to issue SDRs, the intention was to do so to the extent of \$1 billion in each of the first five years, adding over five years some 8 percent to the total gold and currency reserves of the world, which were then standing at about \$70 billion. By the time sufficient countries had agreed to the establishment of SDRs it was decided that the original issue should be on an increased scale: the first three years saw the issue of a total of \$9 billion of SDRs. Of these, \$3 billion were issued on January 1, 1970, \$3 billion on January 1, 1971 and \$3 billion on January 1, 1972. At the beginning of 1979, 1980, and 1981, further SDRs worth approximately U.S. \$4 billion each year were issued, bringing the total to about 21 ½ billion SDRs, worth approximately \$28 billion now.

SDRs are pieces of paper which are issued to each member

country of the IMF and entitle that country to borrow from any other member country a foreign currency needed for balance of payments purposes. Such borrowing is for a limited period and interest is payable. No member of the IMF can be asked by other members to take in SDRs as security for currency borrowing beyond twice its own allotment of SDRs.

The issue of SDRs is made in proportion to the quota or shareholding in the IMF. As this in turn is based on each member's share in world trade, it follows that SDRs are issued to countries in proportion to their share in world trade. This accords logically with the view that extra working capital is needed to enable countries to finance international trade, that is, to purchase goods abroad and pay for them before receiving the proceeds of exports.

When SDRs were decided on as the right way of alleviating the alleged shortage of world liquidity, they were intended to deal with a shortage of working capital rather than a shortage of money in the broader sense. SDRs give countries the chance to spend on imports at times which are seasonally unfavorable to them. They do not enable such countries to increase their total imports in relation to total exports over a long period. They are not intended to help an underdeveloped country make substantial capital investments which will need decades to repay.

Indeed, SDRs have been heavily criticized because they have not given any great advantage to the underdeveloped countries of the world. Such help as they have given has been to each country in proportion to its share in world trade: they have given much more help to the countries which are already rich than to the countries which are still poor. They were not primarily intended to deal with the needs of the Third World.

THE FUTURE OF WORLD LIQUIDITY

The future of SDRs is a matter for serious discussion among experts of every kind. It is probable that further issues of them will be made in increasing quantities in the years to come.
Increases in the currency reserves, especially of those countries with small reserves, are always prone to encourage inflation. Whether such increases in fact do so depends in no small measure on the monetary discipline imposed on themselves by the governments of the countries which receive large amounts of SDRs. The main recipients of SDRs are the industrialized countries of Europe, North America, and Asia.

Already SDRs, which are frequently nicknamed "paper gold," have taken their place in reserves and constitute a proportion of the total monetary reserves of countries which belong to the IMF. They have caused the proportion held in monetary reserves in the Western world in the form of ordinary monetary gold to become less. This proportion will continue to alter in favor of currencies and SDRs and against monetary gold. This means that, with the help of SDRs, nothing stands in the way of the ultimate demonetization of gold. No purpose, however, would be served in rushing this process, but it is undoubtedly a process that has already begun and which cannot be completed without further issues of SDRs.

SPECIAL DRAWING RIGHTS AS NUMERAIRE

In the Guildhall in the City of London there are brass plates measuring 1 foot, 2 feet, 1 yard, 1 metre, 20 metres, 1 chain (66 feet), and 100 feet. These enable the public to compare other measurements with these standard units.

In a similar way, the international value of one unit of national money must be defined in terms of an easily ascertainable, unambiguous, and generally known unit. This is known as the *numeraire*. In the past, silver and gold were used. Thus, from 1967 until 1971, the U.S. dollar was equivalent to 0.88 grams of gold and the pound sterling to 2.11 grams, which gave an exchange rate of \$2.40 = £1.00. The value of 1 gram of gold was fixed as arbitrarily as the brass lengths in the Guildhall (1 troy ounce or 31 grams = \$35). Gold was by common consent the numeraire.

As the dollar-gold relationship was fixed it was also possible to use the U.S. dollar as the numeraire, and to define the value of other countries' currencies in terms of U.S. dollars. This figure, which was made public and had legal and financial significance, is often called the parity or par value of the currency or, more recently and less formally, the central rate.¹

The 1978 Amendment of the Statutes of the International Monetary Fund ruled that future definitions of this kind shall use neither gold nor a national currency as numeraire but a common denominator such as the SDRs (see Schedule C, Paragraph 1 of the amended Statutes of the International Monetary Fund). A number of countries have now defined the central rate of their currencies in terms of SDRs.

SPECIAL DRAWING RIGHTS AS A WORLD CURRENCY

In one way, SDRs, although only an entitlement to credit and not money in the strict sense, have the same use as money. Provided all those who are members of the IMF accept the authority of the Fund and trust each other's promise to accept SDRs as security for loans in national currency, there is no reason why SDRs should not eventually replace all other reserves held by sovereign countries. They could also become the world currency of which the founding fathers of the IMF were dreaming at Bretton Woods.

Such definitions exist and provide the foundation for the eventual use of SDRs as an international currency. The value of SDRs is a composite or basket of the values of a number of national currencies in agreed proportions. Originally one SDR equaled one U.S. dollar. In 1974 it was valued in terms of a basket of 16 currencies. This was changed slightly in 1978 and

¹ This is not to be confused with the middle rate, which is simply the halfway point between the actual market buying rate and the actual market selling rate at a particular moment.

more fundamentally at the beginning of 1981: since then the basket has contained only the currencies of the United States, France, Germany, Japan, and the United Kingdom. The proportions since January 1986 are U.S. dollar 42 percent, French francs 12 percent, German marks 19 percent, Japanese yen 15 percent, and sterling 12 percent.

The final step in the progress of SDRs to their acceptance as a world currency would consist in their replacing all national currencies, having a value defined without reference to any other currency, and, in fact, replacing all other currencies in every-body's daily transactions. All over the world wages would be paid, vegetables bought, bets made, and prices quoted only in SDRs. It is unlikely, however, that this will ever happen. It can be argued that it is not even desirable, as it would presuppose the complete abandoning of national sovereignty in the field of economics.

Any reflections about either the desirability or the likelihood of a world currency also have a relevance to current debates about the desirability or the likelihood of a common currency for all the member countries of the European Community. For this comparatively smaller area too the presence of politically sovereign and economically divergent states poses interesting questions both of feasibility and of the merit of such monetary unification. However, the single currency of the United States suggests that the advantages seem to outweigh the disadvantages over a longer period.

CHAPTER 10

Currency Freedom

In a free world beset by a minimum of problems and blessed with a maximum of material prosperity, the right to acquire and keep foreign currency and such assets abroad as it will buy might be regarded as one of man's freedoms in the economic field. This chapter seeks to examine this concept and to show in which circumstances and to what extent this freedom ought to be limited, as, of course, in most countries it is and has to be.

CONVERTIBILITY

Switzerland has been the country which has most consistently given to her residents the right to buy and hold assets of every kind situated outside her frontiers or denominated in foreign currencies. This ruling makes it possible for any holder of the domestic currency to demand and receive foreign currency at any time. Her currency can therefore be described as fully convertible.

Before any government can allow all holders of its national currency this liberty of conversion in any amount at any time for any purpose, it is necessary for that government to be satisfied that the economy can support the consequences. In other words, the reserves of foreign exchange and the rate at which they grow must be sufficient to cover all such conversions with ease.

Undoubtedly Switzerland, by being able to remain neutral in the two great wars of this century, has succeeded in preserving and enhancing her currency reserves in a way which was beyond the reach of bigger countries with heavy international commitments. It is right to add that the Swiss have been helped by their wise use of natural resources, including the skill, knowledge, and hard work of the population and of the foreigners who live and labor within the country.

Other countries, too, have been able to grant full convertibility of their national currency to their own citizens. The United States has always done so except for a period of limited restriction from 1968 until 1974 (the Foreign Direct Investment Program known as the Johnson Measures). Residents of the United Kingdom were given the right of full convertibility in 1979.

Full convertibility is, however, the exception rather than the rule. Many governments grant to their own residents only a limited form of convertibility, subject to detailed and inevitably irksome rules and regulations. This control over the acquisition and use of foreign exchange has been given the obvious name of exchange control.

WHY EXCHANGE CONTROL?

It is necessary to decide the circumstances in which this type of restriction on the economic freedom of residents may be justified.

Currency Freedom

There are three ways of increasing or at least preserving the national holding of foreign currency, most of which is held by or for the central bank and is shown in the published figures as the currency reserves of the country.

- 1. Foreign currency can be earned by goods sold, services rendered, or inward investments received.
- 2. Foreign currency can be borrowed from foreign governments, international institutions, or other sources.
- 3. Foreign currency can be obtained by selling overseas assets and long-term investments; or by selling domestic assets to nonresident persons or corporate entities.

Of these three methods, the last two are often used, but are hardly desirable. They compare with the private individual's attempt to finance overspending by either borrowing from the bank or selling heirlooms. In most circumstances these are not solutions but stopgaps. The proper course of action (though it is harsh to say so and even bank managers and rich aunts often shrink from putting this view too bluntly) is to spend less or work harder.

In the international context, too, the temptation to live on capital or credit is hard to resist when these ways of countering a shortfall in foreign currency earnings are available. The relative ease with which some governments were able to borrow abroad frequently delayed the taking of harsh and necessary measures to improve the country's international earning power. Such delay hardly ever has any merit except in terms of political considerations and even there it tends to lead to even greater problems in the long run.

The worrying failure of some developing countries to repay their debts or even service their outstanding borrowings belongs to this same category of problems. The term Third World Debt Crisis rightly highlights the financial as well as the moral importance of the situation. Once one accepts that the amounts of foreign currency earned and spent are the key to the long-term preservation of adequate currency reserves, the problem of how to control such transactions presents itself in earnest. The easiest and usually the most immediately effective way is to put direct controls on expenditure. This is why exchange control was originally introduced. It is certainly better than borrowing without prospect of repayment, but it is arguable that it is an improper way of dealing with this sort of trouble. It is like a medicine which brings down the temperature; it does not cure the patient. A case can even be made for the view that exchange control is a form of protectionism that sets up a defensive barrier behind which an inadequately productive or excessively expensive country can shelter.

Exchange control can only be avoided, in a country which is neither exceptionally rich nor unusually successful, if other steps are taken in good time to put the economy on the right road. Such measures may entail restricting wage claims and price increases by strict steps, which can include unemployment, punitive taxation, politically and socially painful cuts in government expenditure, and legislation affecting collective bargaining.

No government can view this kind of program without distaste. The rate of inflation in countries with which its citizens either trade or compete will of course affect the extent to which it is necessary and the time it will take to become effective. It is neither surprising nor wrong to want to gain time by using the protectionism of exchange control to assist, to delay, or even to avoid these measures.

Exchange control is, therefore, a mechanism which wise governments will be loath to dismantle completely. Those who advocate the complete removal of this tool (as would, for instance, have resulted from the repeal of the Exchange Control Act 1947 in the United Kingdom) are allowing liberalism to move them from a very proper respect for economic freedom into a failure to appreciate the social consequences of allowing companies and individuals to dispose of national assets without restriction.

This is not to say that a reduction in the extent to which the acquisition and holding of foreign assets is controlled must not

remain a proper object of governmental policy, especially when allied to a belief in economic liberty and the value of free markets. Politicians can keep and praise exchange control as a machine of government, but they should also make it known that its operation will be kept to a minimum at normal times. Long-term measures to put the economy on the right road are more important than short-term ways of avoiding the penalties that come from allowing it to stay indefinitely on the wrong one.

THE FUTURE OF EXCHANGE CONTROL

In many countries which operate exchange control, so-called current payments are supervised rather than restricted. Imports may be paid for, services rendered by nonresidents remunerated, gifts made, travel undertaken. Restrictions concern details: forward cover can be obtained for limited periods only and documentary evidence has to be produced for most transactions to satisfy the bank handling the foreign exchange deal that a genuine and definite commercial transaction underlies the request for foreign currency.

Most industrialized countries, in accordance with Article VIII of the International Monetary Fund Statutes, allow nonresidents the right to convert holdings of national currency into foreign currency, but restrict similar action by resident companies or individuals.

Restrictions tend to affect mainly the purchase of securities denominated in foreign currency (portfolio investment), direct investment in industrial or commercial enterprises, and the acquisition of land abroad.

NEW INSIGHTS

It is desirable to state clearly two aspects of exchange control which have only fairly recently been recognized as important and which may well affect political decisions about exchange control in the future.

First, exchange control has traditionally been a weapon to control outflows of money. Considerable changes in the currency reserves and therefore in the domestic money supply are, however, caused not only by outflows of money but also by inflows.

Inflows are harder to control because they are usually initiated by nonresidents. The control of inflows is now part of the exchange control philosophy of many governments and has been attempted with a modest measure of success by surplus countries such as Switzerland, Germany, and Austria and even, for a short period in 1971, by the United Kingdom.

Second, an efficient system of exchange control requires a large staff in the offices of the appropriate administrative departments and of the central bank and also the intervention of thousands of well-trained staff in banking and industry. Such deployment of manpower on regulatory activities may not be justified in terms of currency flows prevented by exchange control.

In times of heavy speculation ways are usually found by active and experienced professional speculators to avoid the more irksome consequences of exchange control, unless the regulations are exceedingly restrictive and their enforcement a great deal tighter than is generally the case nowadays.

EXCHANGE CONTROL—A FORM OF PROTECTIONISM

The restrictions on currency convertibility, which are the result of exchange control or similar systems, can be of real help in protecting the currency reserves of a country and thereby in preventing, at least temporarily, undesired changes in the rate of exchange.

The danger is that exchange control will be used as a politically preferable alternative to more fundamental economic measures because it works swiftly and is inoffensive to the average voter. Indeed, spurious arguments alleging that the right to invest overseas may cause unemployment at home (when in all probability the alternative to overseas investment is not domestic in-

Currency Freedom

vestment but noninvestment) illustrate the danger of ill-informed debates about this subject.

Nevertheless, for serious economic reasons as well as on political grounds, measures of exchange control, under this or another name, are bound to increase rather than diminish if financial markets remain free and trade grows. It is therefore necessary to know what exchange control can do to protect national currencies and when and how it should be used.

It is also essential for bankers and for their customers to be fully aware of existing exchange control regulations in other countries and changes likely to occur in those regulations.

nd de Maria de la compositione de la composition de la composition de la composition de la composition de la c Ambignitiste de la composition de la c Composition de la composition della compos

CHAPTER 11

Capital Movements

Countries with important financial and banking centers and currencies widely used for international trade and investments are subject to large and sudden inward and outward movements of money. These may dwarf seasonal and longer-term changes in the balance of trade.

SPECIAL RATES FOR MONEY FLOWS

One way of isolating capital flows and thereby insulating the price of goods, whether imported or exported, against unexpected and violent exchange rate fluctuations is to separate the exchange rate into two rates, one for current payments and the other for capital payments. In the past this method has been used in France, Belgium, and Italy. The investment currency of the United Kingdom, often referred to as the investment dollar or the premium dollar and giving rise to the famous dollar premium which affected overseas portfolio investment by U.K. residents for so many years, was another version of this dual currency system, although it operated only in one direction.

Arrangements of this kind are favored by many financial experts but they are, strictly speaking, contrary to Section 3 of Article VIII of the Statutes of the International Monetary Fund and to the commitments accepted by the signatories of the Treaty of Rome concerning the free movement of capital at the official or commercial rate of exchange.

THE PROS AND CONS

Dual currency systems, which separate the allegedly nonvital payments and receipts of a financial kind from the essential payments and receipts on commercial or current accounts, were strongly defended by certain governments in Western Europe in the 1960s and early 1970s. They were seen as an answer to currency crises brought about mainly by large capital flows. They were deemed preferable to parity changes or to resorting to floating exchange rates or to the increased use of exchange control. They were, in effect, intended to facilitate the maintenance of a fixed commercial exchange rate while allowing the financial exchange rate to float more or less freely.

In practice, dual exchange rate systems work well only when they are not really needed. When pressure builds up, the financial rate is only tenable for as long as the government keeps it artificially near the commercial rate, either by amending the rules or by direct quantitative intervention in the market.

The general philosophy that current payments should not normally be restricted, whereas payments of a capital nature can legitimately be controlled in the interests of the currency reserves

Capital Movements

and the exchange rate, ought in any event to be considered further. Is this distinction between commercial payments, deemed to be good in themselves, and capital payments, which are not necessarily evil but certainly prone to restrictions or price penalties as if they were mere national luxuries, a valid one? This question demands careful thought, lest we become the captives of facile generalizations. Two specific points may form a foundation for this contemplation.

- 1. Certain imports, for example, luxury goods such as fashionwear or drink or exotic food or leisure equipment, or of articles which can be or are being produced in the home market (although foreign makes are thought to be more fashionable, durable or efficient) are not more important for a hard-pressed economy than sensible capital expenditure. The latter will establish, support, or develop suitable enterprises abroad which will bring steady and lasting returns to the domestic investor whether a manufacturing company, a pension fund, or an individual.
- 2. The assumption, widely accepted since World War II and enshrined in so many international agreements, that trade is holy and investment a mere luxury, is often unjustified. Many countries would rather have another country's long-term investments, know-how and management skills added to their own endeavors to build a stronger industrial or agricultural economy than to receive comparable sums in payment for present goods and services; these are likely to leave no lasting benefit and are often a further impetus to local inflation.

CHAPTER 12

Speculators

Few subjects connected with foreign exchange cause more discussion, inflame tempers more severely, or test the ingenuity of the accurate thinker or speaker more than does the term "speculator" and the idea of speculation. There are in fact two kinds of so-called speculators. Before we discuss whether speculation is always right or always wrong or, depending on the circumstances, sometimes right and sometimes wrong, we must try to differentiate between the two different kinds of people who are often described as speculators.

THE TRUE GAMBLER

There are those who purchase a currency because they believe that it will increase in value, because of a seasonal trend or

because of a long-term change in the rate, and who do so for no reason other than that they believe that they might sell again at a windfall profit. They do not need that currency and they will sell it as soon as it has appreciated sufficiently. If they are mistaken they will lose some money; if they are correct they will make quite a lot. This kind of speculation is like buying a share for a quick profit, like backing a horse in a race, like buying a property with no intention of living in it but because one believes that a change in zoning regulations will increase the value of the land drastically in a very short time. It is essentially the action of a consumer who buys something which there is no need for. Equally, it may be the action of a consumer who sells for future delivery something he has not got and hopes to buy back a good deal more cheaply before the date of delivery arrives. Again, if he is mistaken he will have to buy in at a loss, but if he is right he will make a handsome profit.

This type of speculator is the grand speculator; he is rare, he has to be clever to be successful, and he has to be rich to dare to operate in substantial amounts. For all these reasons it is unlikely that he is the kind of speculator who will seriously endanger a currency or disturb a government, although politicians tend to talk about him as if he were the biggest threat to the national currency and to the stability of the national economy.

THE CAREFUL INSURER

The much more common speculator is the man who must, by the nature of his business, be it trade or investment, hold or receive foreign currencies. To him it is not a desire that the value of currencies in relation to his own currency should change, but a threat, a fear, and a danger overhanging his every action. He protects himself as best he can when he hears rumors or suggestions of a change of rate which might affect his business adversely; he will sell at the earliest possible moment a currency which is under pressure or buy at the earliest possible moment a currency which is deemed likely to revalue.

When this is done by a large number of people in many countries it is described as the phenomenon of leads and lags: one group leads or goes ahead of the normal time sequence and the other lags behind or delays. This causes no permanent damage to the national currency which is under pressure, but a temporary outflow of reserves will result. If those who are buying foreign currency are doing so several months sooner than usual, whereas those who are selling it are doing so several months later than usual, this temporarily depletes the reserves and can add to the troubles of the government. It is this kind of activity, born not of an urge to make a quick penny but of a desire to protect one's own business with all the legal means at one's disposal, which is often described as speculative. It is in fact purely protective, although it can in moments of crisis be of a size to put real pressure on, and therefore present a true danger to, the stability of a national currency.

WHOSE SIDE ARE YOU ON?

It is therefore important in discussing both the effect and the morality of speculation to keep apart these two entirely different types of action: the one designed to protect legitimately the business being done by the commercial and investing community; the other, much more rare, much less substantial in size, much more open to doubt by moralists or politicians, which is merely out to make profits. Often speeches or articles which castigate speculation and which blame speculators for the downfall of a currency try to ascribe to the rarer gambler the effects which are, in fact, the result of the legitimate action of the trader or banker protecting by legal means his proper commercial interests. The worst that can be said of such protective actions is that it will accelerate the moment of danger which may or may not lead to a change in the rate of exchange.

The true gambling speculator is rare; it is arguable that his action is not in the national interest. It is much more difficult to find convincing reasons for saying that his action is immoral. He is

doing with money what other people do with stocks, land, and other forms of investment. He is buying what he believes will appreciate and selling what he believes will get cheaper.

Nor is it always easy to draw a clear line between the gambling speculator and the protective merchant, for even the very rich international operator who buys and sells currencies purely for profit will, when challenged, reply that he is in fact protecting the value of his capital and the resulting income with which he does whatever he has chosen to do, good or bad. Thus even if we believed that the pure speculator was an evil man, we might yet find it difficult to discover an actual instance of this rare but much-discussed individual. He is presumably the "Gnome of Zurich" so dear to government spokesmen. He can be blamed for the effect of their own economic mismanagement. His replies are unlikely to be listened to.

ROLE OF THE SPECULATOR

Let us then accept that the real speculators are rare; that those to whom we usually refer as speculators are, in fact, not true speculators and that the result of their action, if sufficiently massive, is likely to accelerate a change rather than to cause it.

Should we necessarily view the action of all types of operators, speculative or protective, as being undesirable? We have lived through many currency crises in recent decades which have tended to give us the impression that speculative movements in the international currency field are disturbing, upsetting, unsettling, undesirable, and to be avoided. At times they have led to a breakdown in the forward market; at other times they have necessitated the actual closing of all foreign exchange markets to the great detriment and worry of those who had legitimate business to transact. Undoubtedly, such extreme crises occur relatively rarely, although we had to live through a number of them in close succession during the years of transition from strictly fixed parities to managed floating.

The action of the speculator is likely to occur on three different levels of intensity. There is, first of all, the action of the true speculator operating in an undistinguished and unsung fashion as a foreign exchange dealer of a banking house, who buys from a customer or sells to a customer a currency which that customer wishes to trade but which the banker cannot immediately cover in the foreign exchange market. In deciding to trade at a rate acceptable to the customer he is taking up a speculative position in that currency by pitting his own judgment about the future trend in price against all the vicissitudes of the marketplace. He is a true speculator and no foreign exchange dealer doing this humdrum kind of transaction day by day and hour by hour at the behest of his customers would be ashamed to admit to being a speculator by profession. His action may not shake the currencies of the world, but it assuredly helps to make the wheels of trade turn. Without it the market would be a less effective place for his customers; prices would be less favorable and, at times, it would be impossible to conclude deals merely because a commercial counterpart is not available. A professional foreign exchange dealer in the bank interposes himself in such a situation by making a speculative judgment and taking speculative action. This is not only the least dangerous but also the most desirable form of speculation. It goes on all the time.

The second kind of speculation occurs when the image of a national currency is beginning to attract the attention of economists, journalists, commentators, and bankers, so that people will either buy it or sell it in the expectation of a change. The resulting pressure on the demand-supply relationship, and therefore on the price of that currency, may be the first public intimation that something is amiss. The action of the speculator, be he the gambling type or the protecting type of our previous distinction, may well give the first indication of an underlying illness. In this case, the speculators are causing a fever which is the signal of a disease; the foreign exchange market is acting as a thermometer to indicate that the patient is in ill health. This function of the speculator is surely a healthy one and, if heeded in good time, it can be of

real assistance to politicians and economists in assessing the underlying aspects of the economic situation.

Finally, it is only when such a situation has got out of hand and far beyond the need of a thermometer, when the patient is not just slightly feverish but plainly in dire distress, that the speculator hastens the onset of crisis. It is only in those rare situations when every other indication and signal, every other warning and comment have been ignored and the situation is almost out of hand that the speculator's function, whether commercially legitimate or not, can be regarded as entirely undesirable from the national viewpoint. That still does not mean that the speculator should be outlawed and forbidden to act. Indeed, countries which prohibit the legitimate covering of forward commitments to their importers at times when the national currency is under pressure, while stopping a real drain on their currency resources, are attacking one of the proper rights of the commercial community. Even when speculation is against the national interest, normally it ought not be forbidden.

GOVERNMENT INTEREST IN SPECULATION

Much speculation, as we have already seen, is the result of the legitimate protection of the interests of an individual or a company in an economic situation which, through no fault of that individual or company, has become a danger to his normal trading or investing activities. In such a situation speculation can undoubtedly be disturbing to the government, but the action of the speculator is in no sense reprehensible or immoral or to be banned by legal measures. To speculate is to take a view about the future. To forbid speculation is to forbid the necessary evaluation of dangers which affect legitimate commercial activity.

The fact that speculation is an activity which at times is beneficial to the market and, therefore, to the market's customers is not to say that it does not at other times cause considerable danger and distress to those in charge of the national currency, namely the government or the central bank. It is, therefore, not surprising that governments should take steps to counteract or lessen the effects of substantial speculation.

This has been organized in an increasing way in recent decades, partly through the framework of the International Monetary Fund (IMF) and partly through other steps within smaller groups of countries, often under the general supervision of the IMF, the Bank for International Settlements, or the authorities of the European Monetary System. Governments can borrow foreign currency in substantial amounts when their own currency is under pressure, and their own currency reserves are therefore dwindling, from countries who are in a more fortunate position. Indeed, these steps were used so frequently during the crises of the mid-1960s that the idea was mooted of making such help almost automatic, and the name automatic recycling was actually given to the scheme, never implemented, which some people advocated to make this kind of aid available as soon as speculative flows of money occurred.

While one welcomes the availability of substantial international aid for countries which are either temporarily gaining or temporarily losing massive quantities of foreign exchange, it is undesirable that this aid should be wholly automatic. It is unreasonable that lenders should be called on to lend, without limit on the quantity or the time of the loan, to countries which are in trouble. It is also unreasonable that countries should be able to receive amounts of money of this magnitude irrespective of other people's judgment as to whether such help is in fact the best way of dealing with the situation. Both lenders and borrowers must be entitled to examine on each occasion whether an adjustment in the rate of exchange or drastic internal measures would not be more appropriate steps for dealing with the causes of the speculative flow of money than their mere neutralization by automatic recycling.

Nevertheless, moving funds from the country which has gained reserves to the country which has lost them has now become an exercise in international cooperation as swift and as substantial as it is ever likely to be, and indeed as swift and as substantial as it ought to be if the warning signal which speculation provides to those in power is not to be entirely lost.

The Causes of Currency Crises and Their Cure

The system of floating exchange rates and the enormous growth of the Eurocurrency markets have made it easier than ever before to delay appropriate domestic action to restore the balance of payments. As a result currency crises can now often be delayed and the steps to cure them postponed. This chapter tries to throw some light on the difficult and far-reaching decisions which governments need to take and on the principles they might follow when they or their neighbors are facing exchange rate problems.

TO TELL OR NOT TO TELL

There is little doubt that the consequences of currency crises are severe, although it may be that the cure is often more troublesome than the ailment. It is undoubtedly unpleasant to hear that the reserves of a country are dwindling, that the balance of payments is in substantial and permanent deficit, and that "something needs to be done." This trend may well continue for a long time without being detected by the population at large, provided nobody in authority draws attention to it.

Attempts to cure the situation involve painful and severe economic measures. Dealing with the currency crisis requires the attention and indeed the collaboration of the entire population.

There have been periods of severe but unseen disturbance for the balance of payments, such as occurred in the United Kingdom immediately before the 1964 general election when, in the absence of governmental comment, the population as a whole was unaware of the seriousness of the situation. However, there have been times, when comment caused people to believe that the crisis was even worse than it was. Often this very process of enlightening the population adds a climate of fearful anticipation and speculation that aggravates the underlying situation rather than resolves it.

No solution is possible in a democratic country unless such a climate of opinion exists, but that is no solution in itself. The belief that the balance of payments is bad leads to gloom, to a flight of capital from the country, and to all kinds of consequences that are harmful rather than beneficial; yet without such an atmosphere the political and economic measures required to achieve a cure are very unlikely to be introduced by the government or accepted by the nation.

It is one of the undeniable penalties of democratic freedom that an understanding of the economic situation by the population at large is a precondition of the government's successful action in improving the situation. For it is the nation, rather than the government, that bears the consequences of the severe measures without which a currency crisis cannot be overcome.

Indeed, it is one of the most difficult tasks of newly elected governments in the east or west, who suddenly succeed a restrictive dictatorship of long standing, that they have to make palatable to the liberated populace the urgent need for economic and financial measures of unprecedented severity. At the very mo-

ment of the long-awaited restoration of political freedom the economic plight of the nation has to be clearly explained and resolutely tackled. This is the more painful when the economic strength of neighboring democracies becomes at long last known and, though admired, is unlikely to be achievable for many years to come.

CAUSES OF CURRENCY CRISES

A currency crisis can be caused in two ways: it can have an external or an organic origin.

External Troubles

Certain currency crises are caused by pressures from the outside which have no direct connection with the economic situation in the country concerned and which cannot be cured by measures taken by that country's government, although of course they can be effectively counteracted. One thinks, for instance, of the severe pressure against the dollar and the pound sterling in the summer of 1969; this was due entirely to the movement into the German mark, which was deemed to be ripe for revaluation and indeed was revalued that autumn. The purchase of German marks put great pressure on less fortunate currencies, such as the U.S. dollar and the pound sterling. This was a crisis caused by external factors and was in fact observed without great alarm by the authorities in the United States and the United Kingdom and the financiers and bankers in New York and London: the dollar and the pound were allowed to decline in the certain expectation that once the German crisis was over they would recover. And so indeed they did.

There are many instances of this kind of action on a national currency, sometimes caused by events in other countries or pressures surrounding other currencies, sometimes caused by speculation concerning the future price of gold or political events elsewhere, resulting in large shifts of money across frontiers. Their effect, if long-lasting, can be detrimental to the currency, but the permanent cure lies outside the control of that government acting on its own.

Organic Weakness

Currency crises of organic origin, on the other hand, cannot be cured by measures taken by foreign governments and present the gravest problems.

The modern international monetary system has provided us with a number of arrangements, some automatic, some subject to relatively quick confirmation in the case of need, which enable a government to borrow additional foreign currency (or lend it if embarrassed by an excess of such currency), to counteract flows of money, whether speculative or commercial, into or out of the currency reserves. These measures are appropriate in a situation in which the interaction of national economies in international trade and the importance of world prosperity is recognized. They should not blind us, however, to the fact that a currency crisis caused by an economic situation in a particular country ought to be dealt with not by palliatives provided by international organizations or wealthier neighbors, but by the resolute action of the country concerned. More specifically, action needs to be taken by the people of that country, guided, and if need be compelled, by that country's government.

Currency crises of this kind are caused in a very simple way, although their recognition may be both delayed and disputed. They are caused by persistent overspending of the foreign currency reserves of the country. As with an individual or a family or a company, a country cannot spend more than it earns unless it has a substantial amount of accumulated capital. Such cases are relatively rare, but they do exist.

The United States consciously and indeed deliberately spent more than it earned abroad for many years after World War II, thus reducing its accumulated currency reserves in an attempt to give money to other nations of the world who required it not only for recovery, but in order to become the necessary export market for American manufactured goods. This action by the United States was, of course, wise and indeed necessary for the economic well-being of the world; but it was made possible only by the enormous accumulated reserves of the United States. The situation has altered now; it exists even less in other countries where the currency and gold reserves, which are the spare cash kept for shopping expeditions in the future, are in most cases barely adequate.

If one accepts the traditional view that it is necessary for a country to hold in gold and foreign exchange as reserves at least 50 percent of the annual import bill, then an examination of the gold and currency reserves of most industrialized countries today reveals that very few of them have adequate backing. Even where there are such reserves, these dwindle very quickly if month after month and year after year the nation spends abroad more than foreigners spend in it.

Currency reserves are simply the accumulated profit from international trade, investment, and other transactions. Whether the earnings are due to exports or to services rendered to foreigners or are the income from past investment, the truth of the matter is that the balance of payments must be in surplus or positive if those reserves are to increase. If the balance of payments is in overall deficit, the reserves will diminish. In most cases, this process of diminution cannot go on for many months before the total size of the reserves appears wholly inadequate to serve the purpose for which they are intended.

The critical size of a country's reserves is a matter of opinion rather than of scientific fact. A substantial change in the reserves in either direction tends to cause comment. Countries which have very large reserves regard themselves as on the verge of bankruptcy when their reserves are reduced to a smaller figure, even though that figure would seem excessively large to some of their neighbors. Because there is no clear standard for the necessary size of national reserves, it is dangerous for any nation to tolerate substantial and persistent decreases or increases in the country's gold and currency reserves without taking action to redress the balance.

DIFFICULTIES OF AVOIDANCE

Except perhaps in the case of the lead reserve currency (at present the U.S. dollar), a persistent decline in the currency reserves caused by an imbalance in the trade figures calls for severe measures to reduce inflation, through steps to deflate the economy by economic, financial, or fiscal means. Where the form of government is democratic and in particular where an election is imminent, it is almost impossible for a government to persuade the population to accept measures which may involve such unpleasant legislation as increasing taxation, raising the rate of interest, or forbidding wage increases, price rises, or the distribution of unlimited dividends. First, it must violently, strongly, persuasively, and protractedly lecture the population on the causes, the extent, and the necessary cure for the crisis which already exists. It is this delay in a democracy between the decline in the balance of payments and the enforcement by government of necessarily stringent countermeasures that can lead to a crisis of such magnitude that it can only be dealt with by a major upheaval like devaluation, or by a policy of deflation far more harsh and prolonged than would have been necessary had steps been taken at the earliest sign of trouble.

It can be argued that currency crises caused not by uncontrollable external factors but by an organic economic situation at home cannot at present be dealt with quickly enough in a democratically governed country. If this is so, then considerable thought ought to be given to the problem.

The nation must accept that a permanent deficit in the balance of payments puts unbearable pressure on the gold and currency reserves and therefore leads inevitably to a crisis and on to a painful cure. We must find ways in which this situation can be made less painful. The population must be made aware by clearer and more intelligible statistics, and by plainer and more honest explanations by those in authority, whenever a situation builds up that will require adjustment or reversal and will get out of hand if such adjustment or reversal is delayed too long. It must become recognized as the duty of a government to give a warning and not

to delay this for political motives until the situation has become a great deal worse.

In recent years there has been a tendency by politicians to avoid some of the more severe economic warnings at times when the party in power could not afford to make political mistakes. The fallacy in this situation is not that politicians are keen to win elections and anxious not to disappoint their would-be voters just before the elections take place. This is normal and natural. Rather, the fallacy is that governments have increasingly spoken as if they were the masters of the economic situation, not merely adjusting here and there by fiscal and financial methods what was taking place in the nation, but shaping the economy of the country in some grand and almost superhuman manner. It is merely a fantasy flattering to politicians and a convenient way by which the civilian in the street can shift blame for economic disasters and difficulties on to "them."

It is the work, the output, and the productivity of millions of people in each country that provide, or do not provide, sufficient goods to keep their country prosperous. And it is the desire for pleasure, for leisure, and for consumer goods on the part of millions of people that causes inflationary pressures in any particular country at any particular time.

Inflation is the reduction in the domestic value or purchasing power of money which occurs when more is being spent and more is not also being produced. It is true that, in a highly centralized and planned modern society, the government can exert a certain amount of influence and control. However, it is plainly false to expect the government to do everything single-handedly and to accept blame, or indeed claim credit, for the economic situation.

It is only when we recognize that it is not the government that makes a country rich or poor but the people, by the work they do and the way they spend their money, that we shall cease to make the economic necessities of the nation subservient to political arguments at election time. Of course economic policy is important and at times overwhelmingly important in the whole field of political activity, but in this, almost more than in any other aspect of government, politicians are dependent on the people

and the intentions of the people in forming, shaping, and guiding the economic destiny of their country. This recognition will enable us to meet the difficulties and dangers in the economic situation and allow governments to guide, warn, and lead the economic endeavor of the nation as a whole without fear of parliamentary defeat or electoral disaster. Otherwise, as political freedom increases in democracies, we are bound to fall more frequently and more deeply into the economic crises that in recent years have tended to nullify, and at times almost to destroy, the political strength of those nations.

DISADVANTAGES OF PERSISTENT SURPLUS

At first sight it is a little more difficult to understand why excessive currency reserves, the result of a persistent and substantial balance-of-payments surplus over a number of months or years, should cause any embarrassment at all.

There are two reasons why currency reserves above a certain level, which have resulted from a persistent surplus in the balance of payments, are undesirable. First, there is no doubt that the arrival of large amounts of foreign currency into a country causes a series of transactions which, if unchecked, have detrimental effects on the economy. The exporter who receives foreign money which neither he nor another trader needs for the purchase of imports, and which therefore becomes part of the surplus of the balance of payments, turns the foreign currency into his own currency by doing a foreign exchange deal with his bank. The bank, in turn, finding that purchasers of foreign currency are scarce (i.e., what we mean by a surplus in the balance of payments), has to sell that foreign currency to the central bank of the country. The central bank adds this foreign currency to its currency reserves, thus showing an increase in the reserves when the figures are next published, usually at the end of the month. This, however, is not the end of the story, because the central bank has

paid for this by giving its own domestic currency in exchange. A surplus in the balance of payments is matched by an increase in the circulation of domestic money, unless special steps are taken by the central bank.

The Canadian government, for instance, made it known after they had changed the parity of their currency by the device of allowing it to float upward in 1970, that one of their reasons for so doing was the difficulty of preventing the Canadian dollar equivalent of foreign currency from being added to the circulation of money in Canada, thereby accelerating the process of inflation. The story of the successive surpluses on the German balance of payments and the long years of struggle to deal with that, culminating in the revaluations of 1961 and 1969 and the decisions to "float" upward in 1971 and 1973, is evidence of the same problem. In other words, a substantial and persistent surplus in the balance of payments is likely to have inflationary effects.

There is a second difficulty. The total reserves of the world do not change except by unusual devices such as the issue of Special Drawing Rights (SDRs). If any country has a surplus on the balance of payments, some other country or countries must have a deficit: if the reserves of one country increase, then the reserves of other countries must decline. The country in surplus cannot idly watch its neighbors laboring under persistent deficits, because its neighbors are, after all, its customers and the surplus is due to its success in selling to them. If that success exceeds certain limits, the governments of these neighboring countries will inevitably have to take measures, whether of deflation or devaluation, to make the excess of imports over exports less marked. This means that the country in surplus will find its own excess of exports over imports reduced by such measures.

A persistent and substantial surplus must therefore be viewed not only as possibly detrimental to the domestic economic situation, but also as a warning signal that the international balance of trade is in a situation which will rapidly become intolerable to the trading partners of the surplus country, and which that country, as much as they, must help to redress.

STEPS TO BE TAKEN

Governments usually consider three types of measures when imbalances in the terms of trade or one-way capital flows threaten to cause a substantial and persistent deficit or surplus in the balance of payments. These measures can be taken either before a crisis develops and speculation adds its weight to the existing and underlying trends, or as soon after the occurrence of such a crisis as is politically possible. These three steps are:

Short-term borrowing
Public relations
Economic reforms

Short-Term Borrowing

Moves can be made with the help of international organizations, such as the International Monetary Fund (IMF) and the Bank for International Settlements, or individual countries with substantial currency reserves, to give temporary aid in the form of loans for short periods or of currency swaps to the countries whose currencies are under pressure.

Such measures will not only give adequate funds to the country concerned, but also assure everybody that international help is available on a substantial scale. This alone may suffice to restore belief that not only the government concerned but its allies, too, will stand by the present exchange rate and will do all they can to undertake and support the economic measures necessary to put things right.

Public Relations

A second measure, linked with the foregoing, is to assure all concerned that the situation has been recognized as being in need of adjustment, that the necessary steps have been decided on, and that they will be taken resolutely, irrespective of the political consequences.

This is not as easy an undertaking as it may sound, as the past 40 years has proved. It is difficult in practice because so often the people addressed are not the people who ought to be addressed. Often politicians are publicly warned of the dangers by their advisers in terms which do not impress the politicians but do frighten the traders who are at the heart of the situation. Sometimes the language is appropriate to the businessperson when the banker should be spoken to, or appropriate to the banker when the statesman in a foreign country is the one actually listening to the speech.

The governments of the world (with few, rare exceptions) are unfortunate in their efforts to calm the waters when the tempests rage. Rarely are their statements as reassuring as they intend or wish. It is not easy to propose a solution. Politicians might often be well advised to consult the foreign exchange traders and some of their industrial customers before making statements designed to reduce speculative pressure. They would quickly be told that what they intend to say might cause greater fear and suspicion, while carrying little conviction.

It is one of the basic beliefs of foreign exchange dealers, and of traders in any commodity, that the best way to stop a speculator selling is to appear as a substantial buyer oneself. No words which tell the fellow that he is mistaken, stupid, or immoral are nearly as effective as the action of the person who actually goes out to buy when the general trend is to sell. This approach is so basic to the philosophy of the marketplace that it is a matter of endless amazement to foreign exchange dealers that at moments of crisis politicians feel it best to make speeches telling the world that the situation is hopeless but that there is no need for panic.

In the process of telling the electorate that the situation is serious and that action needs to be taken, they frequently convince traders that the situation of the currency is desperate. Why be surprised then if speculation, instead of ending, breaks out with renewed vigor? The public relations exercise which should support the management of a currency is a field to which too little attention has yet been paid, but which is crucial at times of pressure or crisis.

Economic Reforms

When international aid of a short-term nature has been given and an improvement in the general climate of opinion through word and action has been achieved, there still remains the removal of the basic situation of imbalance: the need to cure the crisis by removing the causes of it and to bring back into balance the balance of payments. It may even be necessary (particularly if the situation has deteriorated over a long period) not merely to halt but actually to reverse the trend, so that the losses already made may be put right within a period of relatively few months or years.

There is no easy way of doing this. An imbalance in the balance of payments is due to an underlying trend in the movement of money, the origins of which are deeply rooted in the country's economy. The effects of the imbalance have probably developed with accelerating speed over a fairly long period.

The usual situation is that a rate of inflation greater than that in neighboring countries has resulted in a deficit, or a rate of inflation less than that in neighboring countries in a surplus, in the balance of payments. Such trends, being the result of prices and wages and every aspect of the cost of living, cannot be reversed or even made to change direction overnight. It is much easier to restrain such developments than to reverse them after they have occurred.

In the short run, inflation may not cause a deficit in the balance of payments, but eventually it is bound to do so unless other countries with which trade is carried on have similarly high rates of inflation. This is not to say that inflation is harmless if it is indulged in by all countries. The relevant point here, if that is the case, is that its harmful effects will not include a balance-of-payments crisis.

CONTROLS AND RESTRICTIONS

Direct controls on the movement of money between one country and another (such as import quotas, import deposits, exchange control restrictions on the movement of capital, and
many others) can improve the balance of payments, and therefore counteract the effect of inflation on the balance of payments. It is important to recognize that different regulations, particularly in the field of exchange control, operating in different countries, will give unequal advantages to the countries concerned by cushioning the effects of their domestic economic situations on the balance of payments and the currency reserves.

It is true that exchange control is one of the methods that can most quickly and effectively deal with the balance-of-payments effects of runaway inflation (at least for a period). However, the long-term disadvantages of excessive exchange control measures are undoubtedly too serious to be wholly ignored in a community that depends not only on industrial production but also on the free operation of the financial marketplace for its prosperity.

PREVENTION OF CURRENCY CRISES

Although there are now many known cures for a balance-ofpayments crisis, the longer the patient is allowed to ignore the illness and delay taking action to deal with it, the more difficult it is for the doctor to apply the necessary remedies effectively, efficiently, and quickly without doing real damage to the patient's metabolism. Some of the tragic stories of lack of industrial growth and of persistent unemployment and a reduction in the skill of the workforce are the result of deflationary measures taken too late to deal with balance-of-payments crises in highly industrialized countries.

The ideal answer is for complex modern societies to see to it that they watch the effects of domestic economic measures on the balance of payments much more closely. They need to take measures to put matters right at the very earliest signs of damage to the value and stability of the currency. Only harm is likely to result from any delay, such as merely hoping for an improvement in the domestic situation or a worsening in that of neighboring states; resolute action must be taken while relatively minor measures of restraint can still have sufficient results.

The tragedy of the long struggle against revaluation in Germany and the long struggle against devaluation in Britain in the mid-1960s ought to remain as warnings for all time: against hoping instead of acting, and against relying on temporary measures such as international recycling of speculative funds, IMF loans, swap agreements between central banks, and so on, when a long-term solution applied at once is the right answer.

As is sometimes the case in the field of modern medicine, the international financial expert is all too easily tempted to rely on the improved quantity and quality of available medicines to deal with severe economic ills, when these could well have been avoided by early diagnosis and decisive action. Economies tend to deteriorate into economic ill-health far more easily than they could before World War II because the availability of international aid makes the immediate consequences less catastrophic.

THE WORLD DEBT CRISIS

As with private individuals or commercial and industrial companies, failure to take steps in good time to reverse a habit of persistent overspending leads to loss of confidence and withdrawal of credit (the currency crisis of the nations). If temporary overdraft facilities and good advice are then not used correctly and quickly, insolvency follows. For the richer countries this means devaluation, for the poorer ones default.

The long-term solution of the debt crises of recent years is not better banking mechanisms but better management of national economies. It is beyond the scope of this book to suggest whether this is mainly a problem for the less developed countries or for the whole world. Those who cannot help themselves may need to be helped by those who can. Caring and giving has always done more for our neighbors than banking alone; perhaps the entire world needs to move further toward sharing welfare, as many developed countries have already begun to do within their own boundaries.

CHAPTER 14

Eurodollars

The Eurodollar is a new development which has profoundly influenced the money and capital markets of the western world. For the first time in history we moved from the concept of the financial center serving people living outside the national frontiers, as London and New York did in the past, to one of an international center which serves the world and has no one city or country as its focal point. The Eurocurrency concept is the beginning of a truly international and even supranational market, although it still uses national currencies as the vehicle for its operations. The even more sophisticated concept of a money and capital market in currency which belongs to no single country and is expressed in a unit of account such as Special Drawing Rights (SDRs) or European Currency Units (ECUs) is a later idea, still in its infancy.

Eurodollars are dollars which are borrowed by banking institutions outside the United States (including international banking facilities in the United States) from banks or other firms outside the United States. Some of the borrowers are overseas branches of American banks which are among the most important participants in this market. Others are banks anywhere outside the dollar area: they may be in Europe, Asia, Canada, or South America although, as the name of the Eurodollar implies, the initiators of this movement in the 1950s were banks in Europe, mostly in London. When the borrowing or lending is done by a bank in South East Asia or the Far East the Eurodollars are usually called Asian dollars instead.

There are two ways of calculating how many Eurodollars are in existence at any one time. The second way is the one normally used:

1. The lenders of Eurodollars are mostly industrial firms or central banks with accumulations of U.S. dollars on their bank accounts in New York which, for the moment, they wish neither to spend nor to sell. They therefore put them on deposit with, or loan them to, the reputable bank that pays them the highest rate of interest. If the borrower is outside the United States, the lending is regarded as a Eurodollar transaction. It is true, however, that no banker borrows money except to lend it to a user of money; if the money is the national currency of the United States, then the ultimate user must be buying something American. Indeed, the borrower will not take the loan or pay interest until the day on which he or his borrower or the ultimate borrower has to make the payment in U.S. dollars to someone in the United States. If, therefore, Eurodollars are defined as U.S. dollars which are borrowed by a banking institution outside the United States, these dollars, on this view, will cease to be Eurodollars on the same day, because they are usually spent in the United States on the day on which a bank outside the United States borrows and lends them. By nightfall they have reverted to being ordinary U.S. dollars put by an American company into its account with an American bank. There are no Eurodollars in existence at the end of each working day. There are merely dollars.

2. The other way of counting Eurodollars is to include all former Eurodollars, whatever they have been used for in the meantime, until the borrowing bank outside the United States has repaid them to the industrial firm or bank of origin. By taking into account all outstanding loans in this way, the Eurocurrency total becomes very impressive and, in a quarter of a century, has soared from modest beginnings to well over \$4 trillion, of which approximately 70 percent is actually in U.S. dollars.

ORIGINS OF THE EURODOLLAR

Eurodollars came into existence because of Regulation Q issued by the Board of Governors of the U.S. Federal Reserve System, which forbade the paying of interest to depositors above a certain level lower than the banks would otherwise have been willing to concede. However, the prime rate assured American banks a return on money which was higher than necessary in the case of first-class borrowers. European banks were prepared to pay more and charge less, thus cutting the bankers' profit margin; the Eurodollar market, a free money market in U.S. dollars outside the United States, was born. Other factors then greatly contributed to its phenomenal growth. Soviet unwillingness in the early 1960s to deposit large amounts of money in New York in their own name was one of them.

Even the complete abolition of Regulation Q and of the agreed minimum charge for lending at prime rate in the United States would not now spell the end of the Eurodollar market. The convenience of a supranational money market and the development of the appropriate institutional expertise would seem to

ensure that this market will not be disbanded, unless of course governments combine for political or macroeconomic reasons to forbid citizens access to and participation in any money or capital market beyond strictly national boundaries.

USES OF THE EURODOLLAR

The uses of Eurodollars, and to a lesser extent of other Eurocurrencies, are varied and changing. Listing some of the chief types of transaction is not likely to give a complete picture of either the past or the possible future of this market, but it should serve to illustrate the ways in which the market can be used, provided certain general conditions continue to exist.

These general conditions seem to fall into two groups. The first group has to do with exchange control. Many Eurocurrency transactions, as we shall see, are only undertaken because those wishing to borrow are prevented from doing so at home and in their own currency by limitations imposed under some exchange control regulation of their own government. Others are free to borrow but find that in the natural place for such borrowing the banks and other lenders are barred, again by some type of exchange control regulation, from lending for some purposes or to certain classes of borrowers. One of the most common controls imposed in defense of weak reserves is to prevent the lending of the national currency by residents to nonresidents. This often includes lending by resident banks to local subsidiaries of foreign companies.

The second group of conditions has to do with interest rates. In many countries, banking institutions are protected against excessive undercutting, either by mutual agreement or by legal enactments controlling interest rates. Whether these limit interest payable, stipulate a minimum level for interest charged, or do both, their effect is to make any institution not subject to these rules able to select certain transactions and to finance them at rates more favorable to the customer and less profitable to themselves. If the transactions selected are those with little risk and if

the business is an addition to, rather than instead of, the institution's normal activities, the lower profit margin is acceptable. Institutions most likely to be able to profit in this way are banks in another country.

Not all restrictions on interest rates are intended merely to protect domestic banks. Many countries impose such rules to affect the level of credit, the inflow of foreign money, or the flight of domestic capital. Some of these could perhaps be controlled by more direct prohibitions of the kind associated with exchange control; others could not. In any event, countries with little or no exchange control prefer steps which directly (by government order) or indirectly (as by the imposition of reserve requirements for certain classes of deposits) determine interest rates. By so doing, they inadvertently furnish the preconditions for a Eurocurrency market in their currency; and in so far as such a market flourishes, it weakens the effectiveness of the government's controlling measures.

Eurocurrency transactions move the borrowing business from the national financial centers to a foreign place; they do not move the national money, which continues to be banked and spent in its own country.

DEVELOPMENT OF THE EURODOLLAR MARKET

Original customers of the Eurodollar market were firms in Europe and the Far East which found Eurodollars a cheaper way of financing their imports from the United States, and from other areas which demanded payment in U.S. dollars, than borrowing U.S. dollars in New York or their own currency from their own bank at home. Often the borrower was not the actual industrial user, but his local banker whose reputation and international standing not only helped to obtain a lower rate of interest, but also ensured that more ample lending limits were fixed by the lending banks to accommodate growing demand from certain countries and certain industries. Later the Eurocurrency markets were inflated by a variety of new developments, some of which need to

be described here. It is an interesting exercise, important as it is difficult, to decide how far new uses of the Eurodollar market are the result or the cause of its growth.

For many years, the authorities in the United Kingdom encouraged the use of Eurocurrencies for overseas direct investments, because the U.K. reserves were growing at an insufficient pace to allow funds from the currency reserves to be allocated for this purpose. By financing projects through overseas borrowing, whether in local currency or in Eurocurrencies, industrial companies were able to proceed immediately with profitable investments. In most cases the company obtained credit as cheaply as, or even more cheaply than, at home, but took an exchange risk for the whole period of the borrowing. On balance this was much better for most companies than being refused permission altogether, and was possibly almost as attractive as being allowed to remit funds from the United Kingdom at the official rate of exchange. The justification for the arrangement lay in the advantage to the country, which thereby avoided a debit to the currency reserves that would only have been reversed much later.

This call on the Eurocurrency market by U.K. companies indubitably drove Eurocurrency rates upward and therefore helped to attract funds which would otherwise have been invested locally in the United States. This cause of the growth of the Eurodollar market was the more substantial because the authorities in the United Kingdom added other categories over the years. Not only were those seeking direct investments outside the sterling area increasingly forced to finance them through a Eurodollar borrowing, but U.K. companies wishing to make direct investments in the sterling area, foreign companies wishing to make direct investments in the United Kingdom, certain U.K. companies wishing to purchase foreign shares, and even some U.K. institutions and companies wanting to make new investments in the United Kingdom at times of a credit restriction, were forced to borrow foreign currencies to do so. This put upward pressure on interest rates for Eurodollars and other Eurocurrencies. In turn, this attracted lenders of money to these supranational markets.

Very similar effects were felt later on when the United States took steps in January 1968 to control the outflow of funds for direct investment overseas, measures which remained in force until early 1974. Overseas subsidiaries of U.S. companies, finding it in many cases hard to obtain credit from local sources instead, turned increasingly to the Eurodollar market.

At the same time, other measures in the United States resulted in a shortage of money at home, leading many American banks to compete for Eurodollar funds through their own overseas offices. This process of repatriation was the first real link between two competing markets, the Eurodollar market and the New York market, and showed that the use of a national currency for a supranational market inevitably complicates the operation of national economic measures designed to deal with a domestic situation.

One must not exaggerate this difficulty, because the funds in the Eurodollar market are in any case banked in the United States. The movement of funds from a non-American firm, via the European office of an American bank, to the domestic customer in the United States does not by itself increase the amount of credit available in the United States. If this sum were banked directly with a bank in the United States, the effect would be similar.

EUROBONDS

The growing experience of banking institutions in Europe contributed to the development of the Eurobond market, a supranational market for raising long-term capital for use anywhere in the world. This development was made possible by the rapid growth of the Eurodollar market in the 1960s. It depends to some extent on the ability of some houses to borrow short and lend long, which presupposes a pool of money both large and stable.

Eurobonds can be defined as long-term debt securities in a currency other than the currency of the country in which they are issued. The amount of Eurobonds issued annually has grown in 20

years from small beginnings to \$200 billion worth. Of this, nearly two thirds tend to be denominated in U.S. dollars and the rest mostly in German marks, yen, and sterling or in units of account. These can be bundles of currencies specially made up for a particular issue or already existing baskets like Special Drawing Rights and European Currency Units.

THE FUTURE OF THE EUROCURRENCY MARKETS

The willingness, developed over the years, of central banks and international institutions to lend some of their dollar reserves to commercial banks active in the Eurocurrency markets, instead of leaving them with the Federal Reserve Bank, has added greatly to the supply of Eurodollars. It has kept Eurodollar interest rates lower than they would have been otherwise, and has added substantially to the size and consequently to the sophistication and stability of this market. It has also enabled central banks (as became apparent in the prerevaluation crisis in Germany in 1969) to counteract and influence movements in domestic interest rates and in exchange rates, which occur when speculation is on an unusually large scale.

A market which has reached a certain age and a certain size ceases to be a mere phenomenon of a particular decade. It tends to develop efficient and mature institutions. Such developments as the Dollar Certificates of Deposit with a good secondary market, and the establishment of international Eurocurrency brokers who bring together borrowers and lenders in different countries, have added to the institutional framework which supports this relatively new money and capital market.

To some extent the foregoing remarks answer the questions, which are so often asked, of whether the Eurodollar is to remain part of the international monetary scene and what will be its long-term role and significance. No one single change, such as the abolition of exchange control in a major country or the removal of all banking restrictions in one major country alone, would now suffice to destroy the Eurodollar market.

Nor is it easy to visualize the United States alone taking steps which could make the functioning of an overseas market denominated in U.S. dollars impossible, although such measures are theoretically feasible. If, for instance, payments between non-resident banks and others which cannot be shown to be straight foreign exchange deals were subjected to a severe handling charge by banks in the United States, this might make Eurodollar deals uncompetitive. However, it would make institutions seek other Eurocurrencies as an alternative rather than return to old-fashioned financing in New York. Such measures, even if technically and politically feasible, would therefore need to be taken simultaneously by all major countries if they are to be effective in destroying the supranational money markets.

The other way of restricting these markets is for individual governments to forbid their own nationals any participation in these supranational markets either as lenders or as borrowers. If done in unison by many major countries, this would certainly restrict the size and therefore the usefulness of supranational markets.

It is unlikely that governments would take this step unless the supranational markets could be shown to be internationally harmful or dangerous. In the absence of such evidence, governments are unlikely to place restrictions on access to these markets, because it is generally in their own interests to allow it: it enables their own residents to do a variety of useful and profitable things the country's balance-of-payments position makes it impossible to do with their own accumulated reserves of foreign exchange. If anyone is worse off, it is the country whose currency is being borrowed or the country in whose territory the project is being developed, not the country whose nationals are being enabled to proceed by this method.

Furthermore, the substantial share which the commercial banks have taken in the recycling of the so-called petrodollars since the mid-1970s, while not universally approved of, is seen by many as a beneficial way of using the expert knowledge of the banking community in the pursuit of global financing activities.

DANGERS

What then are the international dangers which might one day unite the financial authorities of many countries in deciding to destroy or restrict these supranational money markets? In fact, many of the weaknesses of the Eurodollar market were more in the nature of teething troubles than of organic hazards. Because many loans were arranged by dealers on the telephone or telex there was a risk of lending, often without security, to companies in a foreign country without a full examination of creditworthiness and the complete knowledge of a business derived from years of personal contact between banker and customer. Lending limits are of course fixed in each bank, but unavoidably, where overseas firms are under consideration, only some of the bank's officers are fully conversant with the information which is taken into account in fixing them.

Nor is there any way of knowing whether a borrower has also taken Eurodollar loans from other lenders, adding up to total short-term repayment commitments which are far beyond his means. Whereas in many countries a bank can find out fairly easily its domestic customers' financial arrangements, this becomes impossible where the customer is abroad, new, and fairly large.

It is, however, true that a loss made by a lender of Eurocurrencies as the result of the borrower's inability to repay will also be a loss of currency reserves to the lender's country and therefore a matter of serious concern to its central bank. But these situations are being increasingly avoided as bankers, in the light of past experience both of prewar overseas lending and of Eurocurrency loans, establish practices which assure to Eurocurrency business the same care and safety as is usual in domestic banking. In highly competitive market conditions, this is not always easy; the interests of shareholders and the country coincide in making such care essential.

A different type of problem confronts us when the possible cause of default is not the inability of a specific borrower to repay, but the shortage of currency available to the country in which the

borrower is situated. Whether the borrower is the government itself or a state-owned industry, or an industrial or financial entity in the private sector, such difficulties have become a frequent and serious threat to international banking in recent years. The Third World debt crisis with its very real danger of default by whole nations has become a matter of serious worry to governments as well as bankers and their customers in recent years. Dealing with this has rightly become the subject of international concern and international action.

Other disadvantages of a supranational money market are connected with the degree of independence from national measures of economic control that those participating in such a market are bound to enjoy. There is no reason to begrudge the professionals in the banking world their ability to earn money by giving a service to nonresidents and thereby to earn foreign exchange. It is only when the authorities allow overseas borrowing for domestic projects that there is a net loss of foreign exchange, because residents owe interest to nonresidents. When the authorities do not think this can be justified, they do not allow it: they maintain or establish exchange control to prevent such borrowing beyond the scale they deem reasonable.

The real problems come from the extent to which domestic measures of economic control can be frustrated by the use of the national currency by those outside that control. Often this is compensated for by the advantage, already mentioned, which the use of the supranational market offers to the same country. But is this enough? Has not the Eurodollar made it more difficult at times to control the availability of money in the United States? Has not Eurosterling made it more difficult to combat speculation against the pound?

The Eurocurrencies are not additional money outside the countries concerned, but merely some of that money. The liberty of Eurocurrencies is not in the field of money supply, but in the use of credit.

The impossibility of directing nonresident banks regarding the parties to whom and the purposes for which money is to be lent does weaken governmental control over its own money supply if its currency has a share in the Eurocurrency market. We must therefore expect occasional attempts at control, which will be effective only if they are made jointly by several of the countries involved.

If, however, there ever were to be a supranational or world currency, the weakening of national economic policies would come from the nature of this currency rather than from activities in the supranational money or capital markets.

RISKS TO INDUSTRY

Governments tend to express more doubts about the advantages of Eurocurrency markets than are normally heard from industry. And yet some hesitation ought to be felt by the financial managers of industrial companies before they embark on Eurocurrency transactions. Indeed, many of them devote much time and thought to these difficulties already.

It is often true that a Eurocurrency borrowing makes possible the financing at a reasonable rate of interest of a transaction which would otherwise be made impossible by either a general squeeze on credit or specific controls on overseas expenditure. In such circumstances it is tempting to clutch at a straw without examining its real strength.

There is a disadvantage in Eurocurrency borrowing, apart from the usual problems, such as the viability of the project financed. It is the risk of a change in the exchange rate. This may have to be accepted but must never be ignored by the industrial or commercial borrower of Eurocurrencies.

Repayment of loans will normally come out of the earnings of the project and, more rarely and unhappily, from the general funds of the parent company. It follows, therefore, that the exchange risk lies in the possibility of the borrowed currency being upvalued (after it has been received and before it is repaid) in comparison with the currency in which earnings are expected. Equally, a devaluation of the currency to be received against the currency owed, during the period of the loan, will entail an extra cost to the borrower.

ASSESSMENT OF RISK

The difficulty of assessing the extent of this risk is far greater than the difficulty of honestly admitting its theoretical existence. Each case presents its own special aspects. A general answer can merely point to the most common facets of the problem.

It may not always be easy to predict with any degree of accuracy the extent of the earnings of a new venture during the loan period, nor what exact proportions can be expected in each of a number of currencies or in which future years. Much will depend on the relative ability of sales forces and on economic conditions and import controls in the various countries where sales are being attempted.

Even if precise receipts in each of a number of currencies could be worked out, nobody can be expected to predict accurately over a period of five or seven years whether an adverse change in the exchange rate is merely a possibility or rather a probability. Nor would the knowledge of a probable or certain change during the loan period help in making the decision whether to borrow or not, unless the amount of the change can be predicted. Where a 25 percent devaluation might kill a scheme, a 10 percent devaluation is often irksome but bearable.

In general terms, two rules of thumb can guide one in making the decision, although by themselves they are insufficient to lead infallibly to the right decision.

- 1. The period of the loan is often decisive in assessing whether to accept the inevitable exchange risk. An exchange loss of 10 percent is not compensated by a saving of 2 percent per annum on interest on a three-year loan, but it would be on a borrowing for a 10-year period. Tax rules, of course, need to be taken into account too.
- 2. The other important consideration is a factual and careful comparison of the proposed loan with alternative ways of borrowing. The case where one is considering an alternative which is only different in that it costs slightly more in interest is quite different from the prevalent situation

where exchange control or the exigencies of the money market present the scrapping or indefinite postponement of the project as the only real alternative. In such cases, a rather high exchange risk will be accepted if the project is believed to be really profitable.

In most cases the exchange risks, whether deemed large or small, bearable or unbearable, cannot be covered by insurance. The forward market, the futures market, and the currency options market rarely offer long enough periods and are in any event usually too costly for this type of capital operation. In countries where absence of alternative methods rather than cheapness sends borrowers to the Eurocurrency markets, often there is also a rule which forbids the purchase of the necessary cover on a forward basis.

Only companies with wide international ramifications and experience can hope to avoid the inevitable exchange risk of Eurocurrency operations. This does not in practice need to exclude smaller organizations from these markets provided they remain aware of the dictum: Eurocurrencies involve risks, which are, however, often outweighed by the advantages and opportunities offered.

CHAPTER 15

Forecasting Exchange Rates

This chapter aims to answer some of the questions of principle which deeply concern the businessperson, especially when a system of largely floating exchange rates is in operation.

WHY FORECAST?

Exchange rates, even between two industrialized countries with healthy economies can move against each other by 10 percent or 20 percent in a year. They can also move by that amount and return to the original figure within a few weeks. The second development is much harder to predict than the first. It also

constitutes a much greater risk because, as a consequence of almost arbitrary short-term fluctuations, the decision about the exact timing of a foreign exchange deal can double or obliterate the commercial profit on one's own transaction or on that of one's competitor.

One of the results of the change from fairly fixed exchange rates to largely floating exchange rates in the 1970s was the need to obtain help in predicting both long-term trends and violent short-term fluctuations in the comparative values of national currencies.

Forecasting has become big business. At its best, it is of real help to the troubled operator. At its worst, it is an expensive exercise in trying to know the unknowable. We want to know in advance in which direction an exchange rate will move, by how much, and when.

TWO APPROACHES

There are two common approaches to forecasting exchange rates. They are usually utilized in conjunction with one another, which is good. Unfortunately, they are often expressed in highly technical, very specialized, and frequently mathematical language.

1. The approach that appears at first sight to be the less scientific, sometimes called qualitative, looks at such factors as the trade balance or the money supply situation and its likely effect on inflation and employment. It also considers the currency reserves and changes in their size, overseas assets and overseas debts, the level of investment and the need for modernization or change in industry, the level of and the politically possible changes to exchange control, import duties and taxation, and the world economic situation and its likely impact on domestic production and consumption. Short-term flows of capital; govern-

ment philosophy; electoral prospects; market feelings; interest rates, land prices, and wage rates; social and economic pressures; the age and ability of management in industry and in banking; and the efficiency and effect of trade union structures must all be taken into account.

When you have looked carefully and calmly at all these and at some other factors, you can hazard a guess at the likely changes in the value of the national currency, and at the likely extent and likely timing of such changes.

2. The other method, associated with charts and models and largely dependent on the use of computers, is often called econometric. An initial decision is essential as to which of the economic indicators to include in the model and what weight to attach to them. By now most forecasters accept that this method can work only if it also takes into account the political and psychological factors that play so great and often so unpredictable a part both in the decisions of governments and in the reactions of markets.

METHOD OF FORECASTING

The fundamental ingredient in any currency forecast is gut feeling, which is really the gift of judgment. It is partly intellectual and partly intuitive. It is partly inborn and partly acquired. It belongs to people rather than organizations. This explains why success in the marketplace is achieved by individuals or by wellled teams and not necessarily by well-equipped companies.

Whatever method or combination of methods is used to forecast exchange rates, one fundamental fact must never be forgotten: an exchange rate requires a comparison between two national currencies. Any evaluation of the situation, and of trends affecting the situation favorably or adversely, must take into account the essentially comparative nature of exchange rates. We are not looking at an objective value, nor comparing today with yesterday, but comparing today here with today over there, and tomorrow here with tomorrow over there.

TIMING

By the time fundamental developments of an economic and political kind have begun to be described in newspapers and in specialized periodicals, markets may have begun buying and selling in expectation of the consequent price changes. Alternatively, they might have ignored the suggested developments and thereby have expressed scepticism of the viewpoint the media are presenting. In either event, the market's reaction to the reports gives helpful indications to the business professional. It is, however, too late for genuine forecasting.

Forecasting needs to be done and evaluated and, if appropriate, acted on before the information and its likely effect on the market are publicly known.

In practice, companies exposed or likely to become exposed to exchange risks must make it a rule to obtain and consider views about likely exchange rate changes as soon as a commercial project of their own is being discussed. The conclusion reached must be backed by knowledge and judgment. Optimism must be restrained by the need for caution. Forecasts must be recognized as possibly fallible, as being more in the realm of prophecy than in the arena of certainty. Above all, studies must be updated, decisions reviewed, and conclusions sometimes courageously revised from time to time.

WISDOM

Forecasting exchange rates is necessary and impossible. The good prophet is rare and worth listening to. The best forecaster is more aware of the difficulty of his task than of his remarkable achievements in the past. He remembers that foreign exchange is part science and part art.

The forecaster is most useful to his client when he remembers that a subtle combination of factual knowledge and sensitive intuition are the true ingredients of all successful activities in the marketplace.

CHAPTER 16

Why Exchange Rates Change

We want simple indicators which will enable us to compare the economic performance of various currency areas and help us to predict movements in exchange rates. The wish is perfectly reasonable even though we know it to be impossible to fulfill.

Because we seek straightforward, intelligible, uncomplicated theories to aid us in our task of foreseeing currency developments, we fall prey to popular fallacies. These tend to reign for a year or two and are then replaced by another. This chapter examines briefly some of these theories.

Most of the theories are not in themselves valid as complete and adequate explanations of exchange rate movements in the past or as guides for the correct assessment of likely trends. Their validity, such as it is, lies in the support which is given to them during the height of their popularity. This support may start among academics, from whom it spreads to journalists, who believe that they owe it to their readers to explain events plausibly and simply. The impact of the media is such as to persuade the exchange dealers and their customers to accept the validity of a simple and clear doctrine, which appears to explain the past and to predict the future. At best it is correct, at worst it is respectable; if it leads you astray you will lose money, but you will not lose your job.

One other aspect of these theories is important. If paramount importance is attached to certain indicators at a particular period, then the pointers which these indicators give will be believed and will be acted on. The effect of this is that, at least in the short run, the rates will do for commercial reasons what the indicators predicted on theoretical grounds. The prophecies become conveniently self-fulfilling. The vulgar way of putting this is in the form of a question: how many people have to be wrong to make them right? In foreign exchange, as in any other field, there is obvious danger in getting on the bandwagon. However, it is sometimes even riskier to refuse to do so.

INFLATION RATES AS INDICATORS

The oldest of the popular theories in the field is the Purchasing Power Parity Theory of Money. It states that differential rates of inflation in different countries will eventually lead to a compensating adjustment in the rates of exchange. Under a floating rate system this adjustment will happen continuously; under a fixed rate system it will happen at intervals and take the form of a big change of parity (devaluation or revaluation).

Statistics can be found to prove or disprove the validity of this theory. That it has some validity is undeniable: a country with price increases 5 percent higher than those in other countries each year for four consecutive years will find its goods about 20 percent more expensive in world markets than those of its competitors and will be unlikely to maintain its share in world trade unless it

devalues its currency by about 20 percent. This is delightfully simple, but is it true?

The quality and speciality of its exports; the geographical location of the country and of its markets; the proportion of its products which are exported; the importance of imports for local consumption; the initial level of costs; and the impact of altered profits on industrial or agricultural activity: these and many more will decide whether the Purchasing Power Parity Theory of Money in its simple and pure form is applicable. It is certain that it does not explain many of the biggest exchange rate movements of this century and even more certain that, taken by itself, it is a poor guide for exchange rate prediction.

THE EFFECT OF INTEREST RATES ON EXCHANGE RATES

For many decades it was usual to regard currencies which were borrowed and lent at high rates of interest with suspicion and to try to sell them. Conversely, currencies whose interest rates were low were deemed strong and worth buying.

This theory was easy to justify. If a currency was suspect, you sold it as soon as you got it: you did not hold it or lend it. Therefore, there were few lenders. Nor did you buy it when you needed it: you tried to borrow it and hoped to buy it later, after it had devalued. Thus there were few lenders, many borrowers, and high rates of interest.

The opposite applied to good currencies which are often called hard currencies. Nobody is fool enough to delay buying what is thought likely to appreciate soon. Nor does anyone sell now what may bring a higher price tomorrow. Therefore there are many holders of such a currency who want to lend, but few borrowers. Thus there are many lenders, few borrowers, and low rates of interest. This theory was given additional support by Monetarist economic theory in recent years: the money supply must relate to productivity; cheap and easy credit encourages inflation.

This is not the place to discuss and evaluate how precisely

true these doctrines are. It is, however, necessary to note that high interest rates at a time of strong inflationary tendencies have become symbols of governmental virtue instead of mere signs of currency weakness. This was the great economic innovation of the late 1970s and resulted, briefly one may hope, in the oversimplified view that rates of interest are the only valid indicators of future movements in exchange rates.

This view had two separate justifications.

- 1. Governments must use interest rates to control the money supply and therefore the rate of inflation. The higher the rates of interest, the more heroic and virtuous the government. This is an alarming oversimplification of proper governmental action, as we now tend to see.
- 2. High interest rates will attract money from abroad and low interest rates will drive it out again. This is not true: changes in exchange rates are much more important than even the greatest interest rate differentials between major currencies.

All that is really certain is the following:

- 1. As long as the interest rate/exchange rate relationship is believed in blindly by the majority (as it was in the early 1980s) we are prone to get a self-fulfilling prophecy.
- 2. There are, of course, always individual speculators who at any particular threshold (change in the rate of interest) will think that the extra return on money now justifies the exchange risk and will move some funds out of one currency and into another. This does not mean that the interest rate alone has caused them to take this decision.

TRADE FIGURES AND MONEY FLOWS AS MAJOR INFLUENCES

At times the published trade figures are eagerly awaited. Good or bad figures showing a surplus or a deficit on visible trade are debated in advance, discounted by the market prophets, marveled at upon publication, dissected, disputed, and discussed. Changes for the better or for the worse move exchange rates and even precipitate crises.

Invisibles are less easily understood and provide excellent arguments to foster or counter speculation. Exact borrowings and loan repayments by government are frequently unclear and therefore supply ample material for further confusion.

The balance of trade and changes in the balance of trade are without doubt of great importance in assessing a country's ability to keep to the present rate of exchange. The difficulty lies in doing so with a reasonable degree of accuracy.

The exchange rate expresses the balance between demand and supply of the national currency in the international currency markets. Exports and imports must balance or the exchange rate will move: it is a price like any other.

The trade figures alone are, however, no valid indicator. How important are inward and outward investment? How big are short-term money flows inward or outward, and how likely are they to change? What credit is available, and how much has been and how much will be taken? Are existing loans due to be repaid, will they be repaid on time or ahead of time or will they be recycled? Are some of the figures included in the published trade figures affected by normal or by unusual seasonal factors? Have developments in money markets or changes in exchange control or in government insurance schemes here or abroad altered the size of commercial credit taken or given?

When all this is known, we can begin to cull useful exchange rate information from the published figures concerning the balance of payments.

POLITICS AND FASHION IN A FREE MARKET

Only a fool would seek to obtain all his indications from one area alone. Notwithstanding this, most traders in any market develop over the years an inclination to look to one or two areas for the indicators they find decisive. Their choice is personal and the defense of it should not be too dogmatic.

Economic policy holds the key to political success in today's world. The level of the exchange rate is of paramount importance to the economic and social policy of any government. This is so whether the government believes in trying to put the exchange rate where it wants it or in accepting the level at which the forces of the free market have placed it.

It follows that political decisions or the absence of them can, and often do, override all the economic indicators mentioned earlier. The decisions of governments have considerable influence on exchange rates, even though their power in this field is far from absolute. A good dealer will try to understand politics and politicians.

There is only one force which is stronger than government in a free market. This is the sentiment of the operators in the market. In the case of foreign exchange, these operators are bank dealers, company treasurers, speculators, and central bankers, all of them exercising an influence on the price of currencies by what they say or do not say and by what they do or do not do.

Because these operators are a part of a market they are inclined to share moods and feelings and fears and prejudices. They are subject to collective emotions which are best described as fashions. For many years the dollar was unassailable. Then the mark was in favor and then the yen. The dollar recovered and even the unspeakable pound received some remarkable fan mail when it became a petrocurrency. With the benefit of hindsight most of these moods were overdone and resulted in swings beyond those which were economically justified.

Fashion is the ultimate motive in a market where keeping up with the Joneses is often both easiest intellectually and most profitable commercially.

STAYING AFLOAT IN TURBULENT SEAS

Foreign exchange problems are bewildering and fascinating. Nowadays their successful solution is economically vital to most firms.

Why Exchange Rates Change

In the days of more or less fixed exchange rates under the Bretton Woods system in its rigid form this was true for only a few firms with specially large overseas commitments or very long-term exposures. Today it applies to all who trade or invest across national boundaries.

A combination of factual knowledge and feel for the market, of economic theories and intuitive responses, can lead to the right answer. The way to obtain these and to mix them in their proper proportions is through the growing discipline of risk evaluation and exposure control.

Companies engaged in any international activity must find out the size of their exposure, currency by currency and period by period. They must update it frequently. They must study the likelihood of adverse movements in rates. They must know what proportion of their business such movements would affect. They must obtain economic and political information, which needs to be detailed and sophisticated. They ought to listen to their bankers and to their consultants. And, above all else, they must develop an in-house policy on foreign exchange, designed and applied by a team of managers with relevant knowledge and experience.

CHAPTER 17

The Dealing Room

Most of the full-time professional players in the foreign exchange market work in the dealing rooms of banks all over the world. Many of them are young and yet carry great responsibility. Decisions which can bring big profits or big losses have to be taken quickly and cannot be changed. The nervous strain on these professionals is therefore enormous. This may in part explain why they often seem abrupt and even rude.

Many banks set aside experienced and often older people to act as go-betweens when customers wish to discuss their currency problems with the experts in the foreign exchange trading room and seek advice to help them decide what and when to buy or sell. Nevertheless the most useful collaboration will always occur when professional dealers and corporate customers can talk to each other directly. An understanding of the different lifestyles of

foreign exchange dealers and most other persons with financial responsibilities is a necessary precondition for this. The purpose of this chapter is to facilitate this understanding.

DEALERS CANNOT WRITE

The speed with which markets move and prices change forces professional dealers to avoid all unnecessary distractions during business hours. And markets in different time zones make a 24-hour foreign exchange market feasible so that these business hours are now very long.

Much of the administrative work is left to colleagues whose experience and efficiency is vital but whose talents and inclinations do not lie in trading skills. They are formed in molds more akin to those of other bank employees. They record what has been done and activate the necessary transfers of funds in domestic and foreign currency. They provide the records which are needed for internal statistical purposes, for reporting procedures prescribed by central banking authorities, and for the essential control function of both internal and external auditing.

The telephone and more generally the spoken word is the tool of communication of the professional dealer. He can think clearly and fast while he speaks. The tools provided for obtaining information, making decisions, seeking or giving prices, and for trading in currencies with counterparties nearby or far away are all designed to underpin the mental and verbal acrobatics of men and women who seem nervous show-offs at worst and mathematical wizards and inspired geniuses at best. Calculators, computers, Reuter screens, and brokers' telephone lines all help the process. Simple tools like telexes and dealing slips must not interrupt the fast working of brain and tongue.

OUTSIDERS WANT INFORMATION

Few foreign exchange dealers can explain clearly the complicated things they do. Still fewer can write about them. This is an almost inevitable consequence of the way they operate and must be remembered by those who seek information from them.

There is certainly a real problem here for the financial and commercial community. In few areas is it so difficult to obtain clear advice or intelligible explanation as in this vitally important field of foreign currency trading. General reports in the press and specific answers over the telephone suffer from this essential handicap: the expert speaks fast and often in a technical shorthand suitable only for the marketplace, but the worried customer whose money is at risk thinks slowly and in a less sophisticated language. Yet it is the customer who is the raison d'être and ultimate base for all the turnover, excitement, and fun in the bank's dealing room. Both sides need to recognize the difficulties of communication and the importance of overcoming them.

DEALERS CAN DEAL

Senior dealers have great responsibilities. They need to coordinate and control, as well as plan and explain, the day-to-day trading activities of the team they control. In addition they are dealing themselves and must have the abilities and knowledge of the other members of the team, coupled with the wisdom that comes from experience. Some of this experience was painful. Nobody likes to be wrong and all dealers are wrong quite often. Fame and fortune in the foreign exchange market come to those who are right more often than they are wrong. Nobody is always right.

In most banks the team is divided, precisely or flexibly, according to practical areas, so that one or a few dealers specialize in each important part of the work. Each section might cover one or several currencies, deposits in foreign currencies (Eurocurrency borrowing and lending), or spot or forward trading.

Most dealers have certain fundamental qualities of character and mind which, with suitable training and some experience, make them useful members of the team. They are bankers in one sense, but differ from their banking colleagues in many ways. Some of the qualities which make a good bank employee make a very poor dealer and vice versa.

WHAT MAKES A GOOD DEALER?

Pressure and stress, noise, flashing lights, apparent untidiness, extremes of elation and despair alternating at short intervals, hard words, and tough criticisms wear many people down. But for the natural dealing type they are the bread of life, stimulus and inspiration without which he cannot operate.

Wise men and women take time before deciding anything. The more important the decision or costly the consequences, the longer the time taken. Dealers, however, must learn to decide in fractions of a second, and must be happy to do so. Courage is needed for this, but so is restraint.

It is often said that dealers are born and not made. There is some truth in this. More important, however, than either innate ability or subsequent education is the unpredictable and often unexpected end result: only people who enjoy trading are good traders. The motto of the International Forex Club "Once a dealer, always a dealer" enshrines the truth that, in the last resort, trading is a vocation and not merely a job. This instinct to bargain and to trade (and not merely to fight) distinguishes us from animals; in some of us it is more developed than in others.

There are, it is rightly said, exceptions to any rule, but certain qualities and qualifications are important ones for foreign exchange traders and should be looked for and encouraged:

Honesty

Trustworthiness

Common sense

Sense of humor

Sense of proportion

Humility

Some banking experience

Some knowledge of banking law

The Dealing Room

Numerical skills (but not necessarily any special mathematical skills)

Knowledge of some foreign languages

A quick and clear mind

Hobbies and outside interests to help a dealer relax and regain peace of mind after hectic and stressful days of trading

The quality that will make a dealer really good at his job is, of course, the excellence of his judgment, and this can only be developed through experience over the years. It is based on the instincts which he brings to his job; these can at best be guessed at when he starts work and recognized and developed later on.

CHAPTER 18

New Instruments

Many new instruments have been developed in recent years and some are covered elsewhere in this book. A brief mention of some others and of ways of combining them to deal with particular problems of financing or of risk reduction is attempted in this chapter. However, the speed with which new techniques are being developed and the sophistication of some of them suggest caution and care in their use. Professional advice of high quality and reliable objectivity should always be sought.

It should always be borne in mind that foreign exchange risks (and the likely cost of avoiding them) are greater than interest rate risks. The reason for this is, of course, that interest rates in major industrialized countries tend to move within predictable margins

whereas in a short period exchange rates can move up or down by rather large percentages. They may also move up and down again, or down and up again, within a few months or even weeks or days. Interest rates are more inclined to go in the same direction for quite a while. This direction is usually dictated by visible developments in inflation rates or trade figures or other economic indicators.

INTEREST RATE AND CURRENCY SWAPS

The term "swap" is applied to self-liquidating transactions between two parties. Each party makes a number of payments to the other and receives a number of payments from the other over a period of time. The ultimate value of the payments is similar because the difference in dates accounts for the difference in the actual payments. Market exchange rates for forward delivery measure these differences. Interest arbitrage is an old and well-understood use of the swapping technique involving both foreign exchange rates and interest rates.

Interest rate and currency swaps provide a bridge between primary credit markets. They enable borrowers to use markets all over the world and to seek funds cost-effectively without additional risk.

The recent increase in these activities is a tribute to the growing skill and knowledge of corporate treasurers and is likely to continue. As long as tax laws, exchange controls in different parts of the world, or assessments of credit risks concerning companies and countries differ, there will be room for swap transactions, which are essentially an arbitrage activity.

The liberalization of financial markets in the early 1980s encouraged major industrial borrowers to look for funds in different countries and often in currencies they did not actually need. The lenders, however, vary greatly in their assessment of credit risk: some like certain areas better than others, some prefer governments, and others prefer privately owned corporations.
The wishes of potential borrowers and potential lenders are rarely the same.

An example will illustrate this problem. A U.S. company with an internationally respected image can raise funds in Germany in marks at a very favorable rate of interest. Another U.S. company may be unable to do this, but may be able to borrow U.S. dollars in the United States very cheaply. If, however, the first company wants to borrow U.S. dollars and the second company German marks, then the obvious solution is for each of them to do what they can do best and, with the help of an alert banker, to swap the funds borrowed. This in essence is what the interest rate and currency swap market is all about. By using the status and financial clout of the other each of the two parties has reduced the cost of borrowing money.

It is worth noting that the function of banks in many swap transactions is the important one of introducing, arranging, and managing, but that the actual borrowing is by an industrial or commercial entity of first-class standing. After the bank failures of recent years and in view of the fears engendered by the Third World debt crisis many lenders prefer to lend to corporates rather than to banks.

In the specific area of currency swaps the simplest form is the variable exchange rate currency swap. Here the two parties agree to exchange currency amounts for spot delivery and to reverse the process for an agreed date in the future at an agreed but different rate of exchange. The rate difference is normally dictated by the interest rate differential, as postulated in the theory of interest arbitrage. Interest rate and currency swaps use this fundamental technique to utilize the specific strengths and weaknesses of particular borrowers of prime standing in different parts of the world.

The possibility of entering this swap market also enables a corporate treasurer to alter the pattern of his loan portfolio at any time after its establishment if his view of interest rate developments has changed. The swap market, in fact, provides a secondary market for existing long-term debt. The treasurer needs to be alert and active even when not seeking to make new borrowings.

Timing and amounts are also more flexible in the swap market than in the traditional markets such as the New Issue Market.

FORWARD RATE AGREEMENTS

Forward rate agreements are an alternative to interest rate futures. They enable borrowers to buy insurance, for instance against massive changes in reference rates such as LIBOR (London Inter-Bank Offered Rate) on which the cost of borrowing after the next roll-over date depends. The cost of these agreements tends to be less than the cost of futures, mainly because no margins are charged. The terms too are more flexible. In a sense therefore forward rate agreements (FRAs) can be described as over-the-counter interest rate futures. The market in dollars, sterling, marks, yen and Swiss francs is active and many other currencies can be negotiated.

INTEREST RATE GUARANTEES

Interest rate guarantees are similar to options on future interest rates. A rate is agreed and a fee paid. If the actual rate (e.g. LIBOR) turns out to be less favorable to the recipient of the guarantee, then the guaranter pays him the difference.

This, too, is an insurance against adverse changes in interest rates and follows the pattern of interest rate options but provides greater choice in respect of currency, amounts, maturity dates, and margin requirements than is available in the official options markets.

CROSS-MARKET ARBITRAGE

As new financial techniques are developed and the sophistication of the participants develops in response both to new problems and to novel ways of dealing with them, arbitrage be-

New Instruments

tween instruments offers new opportunities and reduces cost differences.

The instruments most frequently compared by corporate treasurers, their professional advisers in the banks, and the operators in the various markets and relevant exchanges are:

Foreign exchange rates for spot and forward delivery

Interest rate futures

Currency futures

Interest rate options

Currency options

Eurocurrencies

Government paper

Commercial paper

Certificates of deposit

Floating rate notes

Interest rate and currency swaps

Forward rate agreements

Interest rate guarantees

e progressi ve la companya di salah di Januar 1905 di salah di salah

CHAPTER 19

Financial Futures

The use of financial futures is a recent development in the financial markets which began in the 1970s and provides a useful alternative to the more traditional procedure of forward covering.

ITS ANCESTORS

Futures markets in commodities, such as wheat or cocoa, have a long history on both sides of the Atlantic. Their main purpose was and should be to protect traders and manufacturers against adverse movements in price due to crop failures, political upheavals, or economic crises.

By selling or buying on a futures market long before they are ready to trade physical goods they can, in effect, insure themselves against future price changes. When they are ready to sell or buy the physical goods they reverse the original futures deal: the profit or loss on that will be similar and opposite to the amount by which the price for physical goods (or spot delivery) falls short of or exceeds the expected price. Done expertly and within proper limits it works like any insurance and is similar to forward deals in the foreign exchange market: it acts as a hedge.

THE MARKETS

Many futures markets are organized in such a way as to guarantee effectively the standing of the participants through a system of margins. In this way they provide a far-reaching though not absolute assurance of delivery which is of course lacking in the traditional foreign exchange market.

The time may eventually come when the magnitude of exchange rate fluctuations and the consequent danger of default through exchange losses will force the foreign exchange market to adopt a similar system of cash margins for forward deals. Between banks and customers this was widely done in the 1930s. Between banks and banks it would constitute a revolutionary but welcome innovation.

Financial futures contracts commit both parties to delivery and payment at a stated date in the future and at an agreed rate of exchange (price). In this respect they do not differ from forward contracts in the interbank foreign exchange market. The differences are, however, considerable.

The main ones are:

 Financial futures are traded on an official exchange by "open outcry," whereas forwards are negotiated privately between the banks or other participants in a largely telephonic market.

Financial Futures

- 2. Futures contracts are standardized in respect of currency, expiration date, and size, whereas forward contracts can be for any pair of currencies, any amounts, and any delivery dates agreed on by the contracting parties.
- 3. In futures markets the real opposite party is unknown and the partner is the exchange or the clearing house, whereas the counterparty in a forward deal is the actual institution with an opposite requirement. This affects not only confidentiality but also, and more significantly, the magnitude of counterparty risk.
- 4. Futures markets demand and collect both initial margin and variation margin from all participants, whereas the ordinary foreign exchange market (as mentioned above) normally does not. This fundamentally alters the need for capital when entering into foreign exchange deals for later delivery and the risks to which future exchange rate movements expose participants and their backers.

DEVELOPMENTS

The first seven currency contracts were traded on the International Monetary Market (IMM) of the Chicago Mercantile Exchange in 1972. The continuing uncertainties which inflation and floating exchange rates imposed both on exchange rates and on interest rates in the major industrialized countries helped the financial futures markets to grow. In 1982 the London International Financial Futures Exchange (LIFFE) opened and added considerably to worldwide understanding of futures trading. Until then it had been, except for a small band of commodity experts, an area little known or understood outside the United States.

When, in 1984, the Singapore International Monetary Exchange (SIMEX) began operations, it forged links with the IMM in Chicago. This initiated international collaboration of an advanced kind. Paris, Zurich, Sydney, and other cities have since

started futures markets and European Currency Units (ECUs) contracts have been introduced, thus assuring a place for futures markets in any serious currency strategy. The Financial Instrument Exchange (FINEX) now quotes a U.S. dollar index currency future which enables one to hedge U.S. dollars against a basket of other currencies.

PRICING

The exchange rate for any pair of currencies for delivery and payment at a fixed date in the future cannot differ substantially between the forward market and the futures exchanges. Differences due to expenses, cost of margin, creditline availability, timing factors, and the like are relatively small and are calculated by the professionals in both markets. They will then trade between the two markets and, by this arbitrage activity, re-establish equilibrium.

However, the forward market and the currency contracts of the financial futures markets fall equally under the spell of the interest arbitrage rules which inevitably link interest rates and forward exchange rates. The difference between the spot rate and the forward rate for any particular date is equal to the difference between comparable interest rates for deposits in the two currencies for that period. Given freedom from exchange control and orderly market conditions, the swap costs must equal the interest rate differential. This sets clear limits alike on forward rates in the foreign exchange market and on contract prices for currency futures.

USES OF FINANCIAL FUTURES

As with forward contracts in the cash or interbank foreign exchange market, futures contracts of appropriate size and maturity eliminate exchange risks (profits and losses) on currency commitments which are firm (e.g. imports and exports, loan repayments, dividends, and so on) but not yet due.

Currency Options

Futures contracts can be used, as can forward contracts, in connection with contingent exposures in foreign currencies or in the absence of any specific currency exposures, to indulge in speculation. Given sufficient capital this may be an interesting exercise in financial skill. While dangerous for the player, it certainly tends to strengthen the marketplace by increasing liquidity and know-how. At times of crisis, however, it can have destabilizing effects on the functioning of the exchanges and on the costs of genuine trade.

Currency Options

The most important development in the struggle to protect legitimate business against the terrifying risks of currency fluctuations is the relatively recent invention of currency options.

WHAT IS A CURRENCY OPTION?

A currency option contract gives its holder the right to receive and to pay for an amount of foreign currency at a fixed date in the future (a call option) or to deliver and to receive payment for an amount of foreign currency at a fixed date in the future (a put option). This simple definition highlights three fundamental characteristics of currency options:

First, currency options differ from time options used in foreign exchange. Time options merely provide one party of a forward deal with the right to decide later on the exact date of delivery and payment. Currency options furnish a right to receive currency much as ordinary forward deals do.

Second, currency options differ from all other foreign exchange deals, whether for spot or for forward delivery, and from futures deals, in that they do not impose rights and duties on both parties to the contract. In contrast, they impose duties on one party only (the option writer) and confer rights on one party only (the holder of the option).

Third, currency option contracts are not foreign exchange contracts in the ordinary sense. They are insurance contracts, giving the holder protection against exchange risks (for which he pays a premium) and placing upon the writer of the option, in return for the premium he has collected, the duty to pay the holder for any damage he has suffered.

RECENT HISTORY

In the early 1980s, currency options were introduced to the foreign exchange market. At first, the market in this instrument developed slowly. Then, in 1982, standardized currency options began trading at publicly quoted exchanges and interest in the product grew dramatically. Today there are several major exchanges trading currency options and an active over-the-counter options market within the international foreign exchange dealing network.

Even though considerable attention has been focused on this market during recent years, currency option trading is still in its infancy. Only a small proportion of foreign exchange market participants are fully conversant with the use of options as a tool in their currency exposure management, and it will take time before the full potential of the currency options market can be

realized. The exchanges which trade currency options follow the rules of the financial futures markets concerning standardization of contracts, risk reduction through margins payable, and disclosure by open outcry.

Business on the over-the-counter market allows complete freedom to the contracting parties (usually a bank and a corporate customer or two banks). They can write options in any pair of currencies, in any amounts (round or broken), for any date and at any strike price.

Such "made to measure" options have the advantage of fitting the exact needs of the option buyer and of secrecy regarding the details of the contract. For the bigger participants there may also be freedom from expensive and administratively irksome margin requirements resulting from the system of "marking to market."

However, the advantages of the official option markets are: (1) the publication of all bids and offers through the open outcry method which gives public knowledge of premiums charged and paid, and (2) the guarantee system through the margins deposited with the clearing house to eliminate counterparty risks.

TERMINOLOGY

When an option is written by one party and purchased by another, certain fundamentals are established. The option gives a right to buy or sell, at a future date, the stated amount of the "underlying currency." A fee for this right is paid and this is called "the premium" and is expressed in the home currency of the contracting parties ("the base currency").

If the option is a "European Option," it can only be used or "exercised" by the holder of the option against the writer of the option on the final date of the agreed period ("the expiration date"). If the option is an "American Option," it can be exercised on any date up to expiration date. The price at which the option can be exercised is called the "strike price."

THE RISKS

The writer of the option has, in theory, an unlimited risk. He may have to give currency at a horrifying level of cost or he may have to accept currency which has become almost worthless. Like any insurance company he can and should reduce his exposure by some type of reinsurance before the cost has become prohibitive.

Writing options is dangerous and difficult. It should be attempted only by experienced professionals and those with a large enough volume of forward business to enable them to cushion the risks of option writing within the framework of large positions of existing exchange transactions.

In addition, the holder of the option has no risk. He must buy the option suitable to his exposure and from a reputable option writer and efficiently perform what his option contract requires. He has to spend money to obtain his option: in this respect he is like any person who insures against any other risk. He pays a fee (the premium) and obtains the insurance cover he desires.

THE MAIN USES OF CURRENCY OPTIONS

Options can be used (and, in cases of large commitments denominated in a foreign currency, ought to be used) whenever it is uncertain whether a commercial or investment activity will result in a currency payment or a currency receipt or not.

Some of the more common examples of such contingent exchange exposures are:

1. When you tender for a capital project or commercial order expressed in a currency other than your own. You have to use an exchange rate in your calculations, but you cannot fix it by covering forward because at this time you do not yet know whether you will get the order and eventually receive the foreign currency.

A normal forward contract when tendering is risky. Tendering and not covering forward is equally risky: if the

Currency Options

tender is accepted and no forward contract has been arranged, a period of uncovered exchange rate exposure has to be endured; if the tender is unsuccessful, the forward currency contract has to be reversed at market rates, which can result in an exchange loss or profit of unpredictable magnitude. On the other hand, the currency option contract limits the possible loss to the size of the option premium already paid. It is the appropriate tool to use.

- 2. When you are committed to pay commissions, fees, royalties, or dividends in foreign currency, but have as yet no idea whether any amounts will become due or how much or when. Again, a traditional forward deal is inappropriate and could even involve you in losses because you have bought too much forward cover and later have to sell it at a lower price.
- 3. When you are hoping to receive commissions, fees, royalties, or dividends in foreign currency, but have as yet no idea whether any amounts will become due or how much or when. Again, a traditional forward deal is inappropriate and could even involve you in losses because you have sold too much forward cover and later have to buy it at a higher price.
- 4. When you have invested in the international bond market in a foreign currency and movements in exchange rates may result in major losses or produce substantial gains.
- 5. When an asset expressed in foreign currencies (e.g., foreign stocks or international bonds) or an asset realizable only by a sale to a foreigner in foreign currency (e.g., a factory in a foreign country) has to be used as security for a loan at home. A currency option may be comparatively costly but the lending banker may be entitled to insist on it to give the security you offer him a reasonably definable value in home currency.

6. When debts in foreign currencies may require repayment from domestic sources at an exchange rate which may be much more favorable than expected but could turn out to be cripplingly less favorable than expected.

WHY USE CURRENCY OPTIONS?

Until the rate of exchange is established it is impossible to translate costs in one currency into a price in another currency. This can be done only after forward exchange contracts have been signed and this is not possible until a firm contract in a specific currency exists. Until then, a contingent exchange exposure has to be accepted, against which a currency option contract provides complete protection.

OPTION PRICING

To some extent the price of an option is a matter of demand and supply. It reflects the presence of people wanting to write options and of people wanting to protect themselves by buying options. Although the generally accepted view of likely changes in the rate ought to determine the cost, there exists nothing like the insurance industry's normal recourse to actuarial information to guide one about the likelihood of the insured peril occurring and therefore of the proper premium to be charged. Houses over a large area burn down at a rate which does not normally vary greatly from one year to the next. Nothing of the sort can be said about exchange rate movements: a currency which lost 10 percent of its value last year may do so again this year or it may lose 20 percent or gain 5 percent. Who knows?

Nevertheless there are certain rules about option pricing which set the limits within which we may expect the premium charged and paid to be fixed. The concepts of *intrinsic value* and *time value* will help us to understand the pricing mechanism.

The intrinsic value of an option is what it is worth if exercised

now (which with so-called American Options is the option holder's right). Let us assume that he has bought a sterling call option with a strike price at \$1.45. If spot sterling is now traded at \$1.50 per pound he will exercise his option (which means that he will get his pounds at \$1.45) and will sell them in the foreign exchange market at \$1.50. Only two things may stop him: First, if he thinks that sterling will appreciate even more, say to \$1.55, he will be inclined to wait and hope for a bigger profit. Second, if the premium he paid was 5 cents or more per pound this will remove the profit he can make by collecting the pounds to which the call option entitles him and selling them in the market.

What this means in practice is that the premium must be closely related to the intrinsic value, that is, 5 cents in our example. If it were otherwise, the professional arbitrageurs in the market would make a lot of money.

An option which has a strike price equal to the actual exchange rate is referred to as "at the money." An option which has some intrinsic value (is better than the present rate) is called "in the money" and one which has no intrinsic value is called "out of the money."

Time value is the second factor determining the premium and destroys, up to a point, the simple theory just propounded. The longer the remaining life of an option, the greater the possibility of the option becoming valuable and being worth exercising. Therefore the premium for a remoter date is usually more than the premium for a nearer date.

The nearer the strike price is to actual spot rates the more likely it is that the option will become worth exercising during the period of its life. The premium will reflect this. The consequence is that a strike price some distance away from the current level of the exchange rate is a cheaper proposition and may serve the purpose of the option holder. Like an excess clause in an insurance policy it leaves the insured party (the option holder) to carry minor losses but covers him completely for major losses. Small changes in the rate (say up to 5 percent he can afford to live with; higher losses would be crippling and against those he insures

himself by purchasing the appropriate currency option.

The time value of an option on the expiration date is nil. Currency options approaching their expiration date have a declining time value.

Volatility is the magnitude of changes in exchange rates. The greater this volatility, the higher the time value of options. Option writers demand a higher premium for a volatile currency than for a stable one. The likelihood of drought or thunderstorms increases the incidence of fires so that insurance companies are likely to raise the premium charged for fire insurance.

Interest rates affect forward rates. Changes in interest rates must cause changes in forward rates, as the theory of interest arbitrage explained. Therefore changes in interest rates alter the time value of options. For call options the time value increases when domestic interest rates rise or when foreign interest rates drop. For put options the time value decreases when domestic interest rates rise or when foreign interest rates drop.

OPTION PRICING MODELS*

Option pricing models examine the variables described previously and derive the "fair value" or price of the option. Option pricing models also quantify the impact of a change in any of these variables on the option price. It should be remembered that market conditions are not static and the variables influencing the price of an option can change at any time in a dynamic marketplace.

The foundation of present day option pricing theory was published in 1973 by Fischer Black and Myron Scholes. Their work examined the pricing of options on stocks and developed a model which, given certain assumptions, derived an exact solution for the value of a European option when the underlying asset does not pay dividends. Subsequent option valuation models were

^{*} This section is adapted from Jeryl Hack "Currency Options" Arbitrage Rudi Weisweiller, ed, (Woodhead-Faulkner, 1986).

adjusted for stocks paying dividends and physical commodities with associated carrying costs.

Mark Garman and Steven Kohlhaggen developed an option model to price European currency options. Their work takes into account the fact that a currency, unlike a stock where the forward date premium is equal to the riskless interest rate, may be at forward premium or discount depending on the interest rate differential. Garman and Kohlhaggen employ a constant dividend model to value a European currency option. In essence, the Garman-Kohlhaggen formulation is an amended Black-Scholes model which takes into account the currency market's spot and forward relationships which are driven by foreign and domestic interest rates.

To date, a closed form solution for the pricing of American style currency options has not been formulated. Because these options can be exercised at any time prior to expiration, interest rates have an impact on the option value which makes the price of an American option more difficult to quantify. While a European currency option is always priced off the forward rate, an American option may be priced off the spot or forward rate depending on the interest rate differential. It is the interest rate differential which determines the likelihood that an American option will be exercised early. To price American options, basic pricing models are usually combined with a form of numerical approximation to estimate the additional value of the American option.

While it is beyond the scope of this discussion to present an in-depth review of these option models several points should be raised. The models reveal that when an option is priced at its fair value an equilibrium position exists such that a foreign exchange position can be established through a combination of borrowing and investment which in essence replicates the option. Through the hedge ratio, the option pricing models describe the correlation between the option price and the exchange rate at any point in time. By holding a cash position which is continually adjusted according to the hedge ratio, the profit and loss profile of the option can be replicated.

For example, with the sterling spot rate at \$1.40, a sterling \$1.40 call option may have a hedge ratio of .50. This means that for every \$1.00 move in spot the options price will increase by \$0.50. The immediate price behavior of a call on £100,000 could be replicated by purchasing £50,000. For every change in the spot rate it would be necessary to adjust this cash holding. If the spot rate appreciated to \$1.50 the option would be very deep in the money and the hedge ratio could be .98. At this point £98,000 should be held. If the spot rate declined to \$1.35 the hedge ratio might be .30 and at this time only £30,000 would be held.

In a similar manner it is possible to replicate the behavior of a cash foreign exchange position by adjusting an options position according to the hedge ratio. If the sterling spot rate were \$1.35 and a sterling \$1.40 call had a hedge ratio of .30 it would be necessary to buy 3.3 times sterling \$1.40 calls for a change in the premium level of the option to equate to a given movement in the spot rate.

The importance of the hedge ratio cannot be overstated, for it is through the hedge ratio that marketmakers in currency options are able to manage the exposures of their option books.

In addition to the hedge ratio which describes the relationship of the option price to foreign cash exchange rates, option pricing models derive correlations between an options price and changes in volatility, interest rates, and the passage of time.

All option pricing models are based on certain assumptions and, to the extent that these assumptions accurately reflect actual market conditions, the option prices they formulate should be accurate valuations of an option's worth. However, these assumptions may not reflect actual market economic conditions, in which case the options prices will be inaccurate.

Even with inaccuracies it is important to point out that, despite inaccuracies, option pricing models are widely used by marketmakers and professional traders in the marketplace to achieve the following:

1. Calculate historical/implied volatility

Currency Options

- 2. Establish what an options price should be
- Monitor pricing relationships between cash and options markets to ensure that boundary pricing conditions are not violated
- 4. Evaluate trading and hedging strategies
- 5. Manage risks associated with option positions

GENERAL READING

- Anthony, Steven. Foreign Exchange in Practice. London: IFR Publishing, 1989.
- Brown, Brendan. The Forward Market in Foreign Exchange: A Study in Market-Making Arbitrage & Speculation. New York: St. Martin, 1983.
- Christophers, S. A. & Strassel, D. C., eds. The Foreign Exchange Source-book, 1988–1989, Vol. 1, No. 1. Forex Analytics, 1988.
- Coninx, Raymond G. F. Foreign Exchange Dealers Handbook, 3rd ed. Woodhead-Faulkner, 1989.

- Coninx, Raymond G. F. Foreign Exchange Today, 3rd ed. Woodhead-Faulkner, 1980.
- Douch, N. The Economics of Foreign Exchange. Woodhead-Faulkner, 1989.
- Hudson, Nigel R. L. Money and Exchange Dealing in International Banking. New York: Macmillan, 1979.
- Taylor, Jon G. & Mathis, F. John. A Primer on Foreign Exchange. Robert Morris Assocs., 1985.
- Tygier, Claude. Basic Handbook of Foreign Exchange. Euromoney, 1988.
- Walker, T. A Guide for Using the Foreign Exchange Market. New York: Wiley, 1981.
- Walmsley, Julian. The Foreign Exchange Handbook: A User's Guide. New York: Wiley, 1983.
- Weisweiller, Rudi, ed. Arbitrage. Woodhead-Faulkner, 1986.
- Weisweiller, Rudi, ed. The Foreign Exchange Manual. Woodhead-Faulkner, 1986.
- Weisweiller, Rudi, ed. Managing a Foreign Exchange Department. Woodhead-Faulkner, 1985.
- Weisweiller, Rudi. Introduction to Foreign Exchange. Woodhead-Faulkner, 1984.

FOREIGN EXCHANGE LANGUAGE

- Steinbeck, G. & Erickson, R. The Futures Markets Dictionary. New York Institute of Finance, 1988.
- Walmsley, Julian. A Dictionary of International Finance. New York: Macmillan, 1979.

EURODOLLARS

Gallant, Peter. The Eurobond Market. New York Institute of Finance, 1988.

- Lomax, D. F. & Gutmann, P. T. G. The Euromarket and International Financial Policies. New York: Macmillan, 1981.
- McKenzie, G. W. The Economics of the Eurocurrency System. New York: Macmillan, 1976.
- Sarver, Eugene. The Eurocurrency Market Handbook, 2nd ed. New York Institute of Finance, 1990.

FOR THE CORPORATE TREASURER

- Abuaf, N. & Schoess, S. Foreign Exchange Exposure Management. Woodhead-Faulkner, 1988.
- Aliber, Robert Z. The Handbook of International Financial Management. Dow Jones-Irwin, 1989.
- Antl, Boris, ed. Currency Risk. Euromoney, 1980.
- Andersen, Torben Juul. Currency and Interest Rate Hedging. New York Institute of Finance, 1987.
- Argy, Victor. Exchange Rate Management in Theory and Practice. (Princeton Studies in International Finance Series: No. 50). Princeton University Int'l Finan Econ, 1982.
- Bell, S. & Kettell, B. Guidelines on Foreign Exchange. Graham and Trotman, 1983.
- Briggs, Peter. Foreign Currency Exposure Management. Butterworth Press, 1987.
- Chown, John. Tax Efficient Foreign Exchange Management Woodhead-Faulkner, 1989.
- Donaldson, J. A. Corporate Currency Risk. Financial Times Business Publications, 1980.
- Dunis, C. & Feeny, M., eds. Exchange Rate Forecasting. Woodhead-Faulkner, 1989.
- Ensor, Richard & Antl, Boris. The Management of Foreign Exchange Risk. Euromoney, 1981.
- Euromoney staff, ed. The Management of Foreign Exchange Risk. Euromoney England, 1985.

- George, Abraham M. Foreign Exchange Management and the Multinational Corporation: A Manager's Guide. Praeger, 1978.
- Herring, Richard J., ed. Managing Foreign Exchange Risk. Cambridge University Press, 1983.
- Heywood, John. Foreign Exchange and the Corporate Treasurer. A. & C. Black, 1978.
- Howcraft, B. & Storey, C. Management and Control of Currency and Interest Rate Risk. Woodhead-Faulkner, 1989.
- Jacque, L. L. Management of Foreign Exchange Risk, Lexington Books, 1978.
- Jones, Donald L. & Jones, Eric T. Hedging Foreign Exchange: Converting Risk to Profit. New York: Wiley, 1987.
- Kaushik, S. K. & Krackov, L. M. Multinational Financial Management. New York Institute of Finance, 1989.
- Kenyon, P. H. A. Currency Risk Management. New York: Wiley, 1981.
- Lassen, Richard. Currency Management, Woodhead-Faulkner, 1982.
- McRae, T. W. & Walker, D. P. Foreign Exchange Management. Englewood Cliffs, NJ: Prentice Hall, 1981.
- Prindl, A. R. Foreign Exchange Risk. New York: Wiley, 1976.
- Riehl, Heinz & Rodriguez, Rita M. Foreign Exchange and Money Markets: Managing Foreign and Domestic Currency Operations, 2nd ed. New York: McGraw Hill, 1983.
- Ross, Derek; Clark, Ian; & Taiyeb, Serajul. International Treasury Management. New York Institute of Finance, 1987.
- Tiner, John I. & Conneely, Joe M. Managing International Treasury Transactions: Accounting, Taxation and Risk Control. New York Institute of Finance, 1989.
- Walker, T. A Guide for Using the Foreign Exchange Market. New York: Wiley, 1981.

FINANCIAL FUTURES AND CURRENCY OPTIONS

Bernstein, Jake. How the Futures Markets Work. New York Institute of Finance, 1989.

- Chamberlain, Geoffrey. Trading in Options, 3rd ed. Woodhead-Faulkner, 1986.
- Duffie, J. D. Futures Markets. Englewood Cliffs, NJ: Prentice Hall, 1989.
- Fink, R. E. & Feduniak, R. B. Futures Trading. New York Institute of Finance, 1988.
- Hexton, Richard. *Dealing in Traded Options*. Englewood Cliffs: Prentice Hall, 1989.
- Jarvie, Robert Gibson. Futures and Options Markets. Woodhead-Faulkner, 1989.
- New York Institute of Finance Staff. Futures: A Personal Seminar. 1989.
- Powers, Mark J. & Vogel, David J. Inside the Financial Futures Market, 2nd ed. New York: Wiley, 1984.
- Redhead, Keith. Introduction to Financial Futures and Options. Woodhead-Faulkner, 1989.
- Sarnoff, Paul. Trading in Financial Futures. Woodhead-Faulkner, 1985.
- Stewart, T. H., ed. *Trading in Futures*, 5th ed. Woodhead-Faulkner, 1989.
- Understanding Foreign Exchange Options. Philadelphia Stock Exchange, 1983.

- ilaj ir kari. Tijakurri ilijakurika 1906. Historia
- A country of the control of the cont
- - grafe (f. 1995) ar said a stadt fræm er i kriger fram er stadt fræmer. Fram gaftette er stadt for fler fræm i fram er stadt er stadt fram er stadt er stadt er stadt er stadt er stadt

Acceptance House. Financial institution in the United Kingdom lending money on the security of bills of exchange. Acceptance houses often lend money to an exporter to cover the gap between the production of goods and the receipt of proceeds from their sale.

Accepting Houses Committee. The 17 leading London merchant banks. Bills of exchange drawn on them are discountable at fine rates. The Committee also ensures policy coordination between its members, the Treasury, and the Bank of England.

Adapted from Eugene Sarver, The Eurocurrency Handbook (New York Institute of Finance, 1988).

- ACUs. See Asran Currency Units.
- Agency Bank. A foreign bank in the U.S. market, authorized to grant loans, but not to accept local deposits.
- All-In Costs. Total costs, both explicit and others (for issuing CDs, etc.).
- Arbitrage. Simultaneous purchase and sale of a security or other financial interest to take advantage of price/yield differentials.
- Asian Currency Units (ACUs). Special department of local and foreign banks in Singapore authorized to conduct Eurocurrency operations.
- Asian Dollar Bonds. Eurobonds issued in Singapore.
- Asian Dollar Market. The Eurocurrency market centered in Singapore.
- Balance of Payments. Tabulation of financial transactions of a country with the rest of the world.
- Bank for International Settlements. See BIS.
- Bank of England. The U.K. central bank, founded in 1694 and nationalized in 1946, as result of which it is controlled by the Chancellor of the Exchequer.
- Bank of France. The French central bank, founded in 1800 and nationalized in 1946, with 233 branches throughout France.
- Bank of Japan. The Japanese central bank, founded in 1882 and reinstituted in 1942, with 45 percent private shareholders but under complete government control.
- Bardepot. A West German regulation which requires a percentage of foreign borrowings by German residents (corporations) to be deposited in cash in a noninterest-bearing account with the Bundesbank.
- Basis Point. One hundredth of a percentage point (i.e., 0.01%).

- Basket Currency. An artificial currency made up of national currencies in known proportions.
- Bid. The highest price/lowest yield that a dealer is prepared to pay for a security/deposit.
- BIS. The Bank for International Settlements, located in Basle, Switzerland, is an intergovernmental financial institution, originally founded in 1930 to assist in transferring World War I reparations among central banks. Now it functions as a "central bank for central banks," with activities including collecting and disseminating information on the Eurocurrency market.
- Branch Bank. A branch of a foreign bank, authorized to make loans and take local deposits.
- Bundesbank. The Deutsche Bundesbank, the German central bank, was founded in 1957. Controlled by a 16 member Central Bank Council which meets every other Thursday, it is totally independent of the federal government.
- Call Money. Money that is immediately available, generally accruing interest at the overnight rate.
- Call Option. Contract giving the holder the right to buy a financial future or other underlying interest at a specified price until an expiration date.
- CD. See Certificate of Deposit.
- CEDEL. Centre de Livraison de Valeurs Mobilieres, Luxembourg. A computerized clearing system for Eurobonds and other securities.
- Central Bank. The major regulatory bank in a nation's monetary system, generally government controlled. Its role normally includes control of the credit system, the note issue, supervision of commercial banks, management of exchange reserves, and the national currency's value, as well as acting as the government's bank.

- Central Rate. A middle rate of exchange used for statistical or policy purposes only.
- Certificate of Deposit (CD). Interest-bearing negotiable time deposit of fixed maturity, but of fixed or variable interest rate, at a commercial bank.
- Chicago Mercantile Exchange (CME). The exchange housing the International Monetary Market, where Eurodollar futures and options are traded.
- CHIPS. The Clearing House Interbank Payments System, the international private clearing system in New York City for Euromarket transactions, with 142 bank participants, including 21 "settling participants."
- Closing Out. Action offsetting a long or short position.
- Closing Price. Price recorded by an exchange at the close of a trading session.
- CME. See Chicago Mercantile Exchange.
- Co-Manager. In security issues, an invitee on an ad hoc basis by the lead manager or at the request of the issuer, who shares responsibility for pricing and placing the issue.
- Commercial Paper. Promissory note of a corporation, government agency, or bank holding company, usually unsecured, but with bank backup lines, normally with a maturity of up to 270 days and sold at a discount from face value.
- Commitment Fee. Fee charged by banks on the unused portion of a loan.
- Composite Currency. Also known as a "currency cocktail," a unit composed of several currencies, such as ECU and the SDR, or a customized unit created by a central bank for foreign exchange management purposes.
- Concordat. The 1975 statement of guidelines by the so-called Basle Committee of the Group of 10 plus Switzerland central bank supervisors (outgrowth of the Cooke Committee) under the auspices of the BIS, providing for the supervision of banks' foreign establishments.

- Convertible Eurobonds. Straight bonds with option to convert into equity shares of issuing company; bonds and shares may be denominated in different currencies.
- Corset. Limitation on the growth of bank lending in the United Kingdom where banks had to make a noninterest-bearing deposit with the Bank of England if the limit was exceeded (abandoned in 1980).
- Country Risk. Risk of lending funds or making an investment in a particular country.
- Coupon. Interest rate payable on bonds (also the corresponding detachable certificate).
- Cross Default. Clause in a loan agreement stipulating that default by borrower on any other loans will be regarded as a default on the one governed by that clause.
- Creditor Nation. Country with a balance of payments surplus.
- Credit Rating. Overall creditworthiness of borrower. (Moody's and Standard & Poor's are rating agencies.)
- Currency Cocktail. See Composite Currency.
- Current Account. The balance of payments account including trade in goods and services plus unilateral transfers.
- Dealing Room. Office where foreign exchange traders work.
- Dealing Slips. Provisional, usually hand-written pieces of paper on which foreign exchange traders record deals done by them.
- Debenture. A bond secured by a general guarantee.
- Debtor Nation. Country with a balance of payments deficit.
- Debt Service Ratio. Cost to a country of servicing the annual principal and interest payments on its debt relative to exports (20 percent is generally an acceptable maximum).
- Demonetization. Abolition of monetary function of a material, usually gold.

- Discount. The amount by which something is cheaper than something else (e.g., forward compared with spot).
- Discount Houses. London financial institutions dealing in money market instruments, twelve of which have a special relationship with the Bank of England.
- Discount Securities. Money market instruments issued at discount and redeemed at maturity for full face value.
- Drawdown. Drawing down of funds made available from a financial institution.
- Droplock Loan. Medium-term floating rate facility that automatically becomes a fixed rate bond if interest rates fall to a predetermined level.
- Dutch Auction. Auction where the lowest price needed to sell the entire offering is the price at which all the securities being offered for sale are sold.
- ECU. European currency unit, a composite currency, created in 1979 by the European Economic Community, and composed of the German mark, the French franc, the British pound, the Italian lira, the Dutch guilder, the Belgian and Luxembourg francs, the Danish krone, the Irish punt, and the Greek drachma; worth approximately \$1.15 (4/87).
- Either Or Facility. Arrangement allowing a U.S. corporation to borrow Eurodollars from a foreign bank (at LIBOR plus spread) or dollars (at prime) from the bank's head office.
- EMS. European Monetary System, the 1979 successor to the European Joint Float, is composed of West Germany, France, Italy, Netherlands, Belgium, Luxembourg, Ireland, and Denmark; 4.5% wide bands are utilized, aside from Italy (12%).
- Entrepôt. A major international trading center to which goods are shipped for re-export elsewhere (literally, a warehouse).
- Equivalent Bond Yield. The true annual yield on a discount instrument.

- Eurobonds. Bonds denominated in Eurocurrencies.
- Euro-Clear. A computerized system in Belgium for Eurobonds and other securities.
- Eurocommercial Paper. Short-term (generally three or six months) promissory notes issued in the Euromarket on a nonunderwritten basis.
- Eurocredit. Medium-term Eurocurrency credits.
- Eurocurrency. Currencies deposited or borrowed outside their native land.
- Eurodollars. U.S. dollars lent to or borrowed from a bank outside the United States.
- Euronotes. Short-term (generally three or six months) promissory notes issued in the Euromarket on an underwritten basis.
- European Currency Unit. See ECU.
- Federal Open Market Committee. See FOMC.
- Fedwire. The preeminent U.S. domestic bank clearing system, managed by the Federal Reserve System and utilizing depository accounts at Fed banks and branches.
- Fiscal Agent. The bank-appointed agent for a Eurobond issue.
- Fixing. A publicly agreed exchange rate for the day, normally arrived at on a physical foreign exchange market (foreign exchange bourse) in a recognized financial center in Europe.
- Floating Rate Note (FRN). A five to seven year Eurosecurity, with generally a six-month rollover rate and a minimum rate.
- FOMC. The Federal Open Market Committee is composed of 12 voting members, including the Fed Chairman (Chairman), the President of the New York Fed (Vice Chairman), the other six Governors and four of the remaining eleven Fed presidents on a one-year rotational basis. Meetings are held every six weeks.

- Foreign Bonds. Bonds issued in foreign domestic capital markets (in the domestic currency); defined as international bonds but not as Eurobonds (Yankees, Bulldogs, Samurais).
- Foreign Exchange Premium/Discount. The difference between the spot and outright forward rates.
- Forward Forward. The future delivery of a deposit maturing on a further forward date.
- FRN. See Floating Rate Note.
- Gearing. The capital: debt ratio.
- Gen-Saki Market. The repo market conducted by Japan's security houses.
- Gilts. United Kingdom government securities.
- Grace Period. Length of time before which loan repayments are due (also before which the commitment fee is applied).
- Group of Ten (G-10). The principal industrial countries within the framework of the IMF, composed of the Belgium, Canada, France, Great Britain, Italy, Japan, Netherlands, Sweden, the United States, and West Germany. Switzerland is associated with most G-10 meetings. (G-3 includes the United States, Japan and Germany, while G-5 adds France and the United Kingdom, and G-7 adds Italy and Canada.)
- Hot Money. Funds held mainly by foreigners, which are liable to be converted suddenly into another currency for speculative reasons.
- *IMF*. International Monetary Fund, which provides temporary balance of payments assistance and is actively involved in resolving international debt problems.
- IMM. See International Monetary Market.
- Institute of International Finance. Composed of major banks throughout the world and located in Washington, DC, it monitors conditions in borrowing countries.
- Interest Basis. Usually 360 days, but 365 in the case of the British and Irish pounds, Kuwaiti dinar, and sometimes the Belgian franc.
- Interest Equalization Tax. A U.S. tax of up to 15 percent from 1963 to 1974 on most foreign securities (stocks and bonds).
- International Monetary Fund. See IMF.
- International Monetary Market (IMM). The CME division that trades Eurodollar futures and options.
- Ioint Venture Bank (Consortium Bank). A bank owned by several other banks.
- Kiwi Paper. Securities denominated in New Zealand dollars.
- Lead Manager (Lead Underwriter). Manager who leads a Euroissue.
- LIBOR. London Interbank Offered Rate of Interest.
- LIFFE. The London International Financial Futures Exchange, where Eurodollar futures and options on the futures are traded.
- Limit Up and Down. Maximum price advance or decline from the previous day's settlement price permitted in one trading session.
- Listing. Listing an issue on a stock exchange, representing the latter's approval for trading.
- London Dollar CD. A Eurodollar certificate of deposit (CD) issued by a bank in London.
- Long Funding. Liability maturity exceeds corresponding asset maturity (i.e., ARBL or asset repriced before liability).
- Merchant Bank. An investment bank, especially in London (e.g., the acceptance houses).
- Money Supply. Monetary aggregates including M-1, M-2, and M-3.

- Net Accessible Interest Differentials. The difference between two Eurocurrency deposits of the same maturity, being net (free of withholding taxes) and accessible (available to all market participants as opposed to the restricted availability of many domestic markets).
- NIF. Note issuance facilities are underwriting commitments of as long as 10 years for short-term note issuance.
- Nostro Account. Bank's account held with a foreign bank.
- Note Issuance Facilities. See NIF.
- Numeraire. Exchange rate for a currency or for a basket of currencies used for purposes of calculation or comparison.
- OBUs. See Offshore Banking Units.
- Odd Dates. Deals for periods other than regular market periods which are generally 1, 2, 3, 6, 9, and 12 months.
- Offer (Asked). The lowest price/yield that a dealer will accept for a security/deposit.
- Offshore Banking Units (OBUs). Special departments of banks in Bahrain, Manila, and Taipei authorized to conduct Eurocurrency operations.
- Option Eurobonds. Straight bonds with option to receive interest and/or principal in a different currency.
- Paper Gold. Nickname of special drawing rights.
- Parity. See Par Value.
- Par Value. Official value of currency (defined in terms of gold, special drawing rights, or another national currency) as made public under a system of fixed exchange rates.
- Perpetuals. A debt issue, generally at a floating rate, with no maturity.
- Petrodollars. Colloquial term for large accumulations of dollars due to oil transactions.

- PHIL. The Philadelphia Stock Exchange, which offers European style options on Eurodollar deposit rates.
- Premium. The amount by which something is more expensive than something else (e.g., forward compared with spot).
- Reference Banks. A group of banks whose interbank lending rates to prime banks are used to determine the interest rate on floating rate securities and loans.
- Rescheduling. Renegotiation of terms and conditions of existing borrowings.
- Reserve Currency. Currency in which other countries keep their foreign exchange.
- Round Turn. A completed futures transaction of purchase and subsequent sale (or vice versa).
- SDRs. Special drawing rights are IMF currency units, composed of U.S. \$.54, DM. 46, £.071, FFr. 74 and Y 34; worth approximately \$1.29 (4/87).
- Secondary Market. The market for seasoned securities.
- SFE. The Sydney Futures Exchange, where Eurodollar futures are traded.
- Short Dates. Standard Eurodeposit periods from overnight up to three weeks.
- Short Funding. Asset maturity exceeds corresponding liability maturity (i.e., LRBA or liability repriced before asset).
- Short-Term Note Issuance Facility. See SNIF.
- SIMEX. The Singapore International Monetary Exchange, where Eurodollar futures and options are traded.
- SNIF. Short-term note issuance facility (same as NIFs).
- Sovereign Risk. Risk resulting from government action (such as freezing assets) or nonaction (failure to pay direct or guaranteed loan).

- Split Spread. Different spreads over LIBOR for different periods of the credit.
- Spot. Currency traded for immediate delivery.
- Spread (Margin). The margin over LIBOR charged a borrower.
- Squeeze. To dry up a Eurodeposit market to support the spot currency.
- Straight Bond. A bond not convertible into equity (plain vanilla).
- Straight Eurobonds. Fixed coupon with a maturity of up to 25 years.
- Sterling Area. Unified currency area combining the currencies of most members of the British Empire or Commonwealth until after World War II.
- Strike Price. Price at which currency can be sold or bought under a currency option contract.
- Subsidiary Bank. An independent legal entity owned by another bank.
- Subordinated Debt. Junior debt, as opposed to senior debt.
- Swap. A pair of foreign exchange deals in opposite directions for different delivery dates but similar amounts.
- Swiss National Bank. The Swiss Central bank, founded in 1905 with its legal/administrative headquarters in Berne and its directorate in Zurich.
- Syndicated Eurocredit. A medium-term loan, denominated in a Eurocurrency, granted by a group of banks, at a spread over a floating rate of interest (usually LIBOR).
- Tap CD. Certificates of deposit (CDs) written on an ad hoc basis.
- TED Spread. A Eurodollar futures strategy involving the changing differential between the Treasury bill future and the Eurodollar future.

- Third World Debt Crisis. Situation caused by developing countries being unable to repay borrowed money or to pay on time interest payments due on debt.
- Tombstone. Advertisement of a syndicated credit issue.
- Tradeweighted Index. A system of comparing the value of a currency today with its value on a known and fixed date in the past, but comparing its value against a group of foreign currencies according to their significance for imports and exports rather than one foreign currency only.
- Tranche CDs. Large certificate of deposit (CD) issues sliced into tranches for retail marketing.
- Two-way Market. Market where dealers quote both buying and selling rates.
- Warrants. Warrants provide the option to purchase shares of issuing company; may be traded separately from the related bonds.
- Werner Plan. A 1971 scheme for unifying Europe's currencies, devised by a committee of which Pierre Werner of Luxembourg was chairperson.
- World Bank. The International Bank for Reconstruction and Development, traditionally a project lender, but becoming involved in global debt solutions.
- Zero Coupon Bond. A discount basis instrument that pays no interest until maturity, and is redeemed at par value.

요. 그 그 아이들은 사람이 살아 살아 있다는 사람이 살아 가셨다면 하셨다.

Index

A American option, 177, 181, 183

D

Balance of payments. See
Currency crises
Bank for International
Settlements (BIS), 51, 52, 126
and speculation, 115
Base currency, 177
Basket currencies, 59–61
Basle Agreements, 61–62
BIS, 51, 52

Black, Fischer, 182
Black Scholes Model,
182–183
Bretton Woods, 52–53, 56, 58–
59

C

Call option, 175, 182
Capital movements, 105–107
Capital payments, 105–106
Central banks, intervention in foreign currency exchange, 7–8, 53–56. See also
Werner Plan

Certificates of deposit, 167 Currency reserves, 66-69, 84-85, 90-91 Chicago Mercantile Exchange, and currency crises, 121 surplus of, 124 Commercial paper, 167 Commercial payments, 106-107 Currency swaps, 167 Convertibility, of foreign Current payments, 105–106 currency, 97-98 D Covered arbitrage, 41-43 Dealers, in foreign exchange, Crawling peg system, 57-58 157-161 Cross deals, 20 Cross-market arbitrage, qualities of, 160-161 Dealing systems, foreign 166-167 exchange market, 9-16 Cross rates, 20-21 Delivery date, 18 Currency areas, 63-65 Discount, 19 Currency crises Dollar Certificates of Deposit, avoidance difficulties, 122-124 138 Dollar, U.S. causes of, 119-121 controls and restrictions, exchange rate and, 53 as reserve currency, 68 128-129 Dual currency systems, and effectiveness of Bretton 106-107 Woods, 56 measures to be taken, 126-128 Econometric approach to prevention of, 129-130 forecasting, 147 surplus, disadvantages of, ECU, 61 124-125 world debt, 130 Emminger, Dr. Otmar, 91 EMS. See European Monetary Currency freedom, 97–103 System convertibility, 97-98 Eurobonds, 137-138 exchange control, 98-103 Currency futures, 167 Eurocurrencies, 167. See also Currency options, 167, Eurocurrency market Eurocurrency market, 13-14 175 - 185and balance of payments, history of, 176-177 main uses of, 178-179 117 future of, 138-139 option pricing models, Eurodollars, 131-144 182-185 pricing, 180-182 dangers and risks, 140-144 terminology, 177 Eurobonds, 137-138 time options compared, 176 market, development of,

Eurodollars Cont'd 135-137 Financial futures, 169-173 origins of, 133-134 Fixed exchange rates, 53, 55, uses of, 134-135 150 European currency, 71-77 Fixing, 14 advantages and Floating currencies, 59 disadvantages, 76-77 Floating exchange rates, 7, 8, European monetary system, 54, 55, 57 75 - 76and currency crises, 117 "the snake", 74-75 as indicators, 150 Werner Plan, 72-74 Floating rate notes, 167 European Currency Unit Forecasting exchange rates, (ECU), 61, 131 145-148 European Monetary Foreign currency exchange, Cooperation Fund, 75 25 - 38European Monetary System banks' role in and selection (EMS), 7, 53-54, 75-76 of, 35-38 and speculation, 115 invoiding, 31-35 European option, 177, 183 spot and forward covering Europe 1992. See European compared, 26-29 currency time option and swap Exchange control, 98-103 compared, 29-31 See also Exchange Control Act 1947, European currency and 64, 100 Interest arbitrage Exchange rates Foreign Direct Investment changes in, 149-155 Program, 98 current and capital payments, Foreign exchange bourse, 105-106 14-15 fixed, 53, 55 Foreign exchange dealers, fluctuations in, 52-54 157-161 forecasting, 145-148 Foreign exchange market interest rates, effect on, brokers, 10-13 151-152 centers, 16-17 currency options in, 176-177 political influence on, daily meeting, 14-15 153-154 dealing systems, 9-16 trade figures and money flows, influences of, deposit brokers, 13-14 151-153 See also direct dealing, 15-16 European currency fluctuations in, 52-54 Exports, invoicing in foreign how it works, 9-23 currency, 31-32 intervention in, 54

Foreign Exchange Market Cont'd IMF. See International language problems, 17-18 Monetary Fund terms, 18-22 See also Imports, and foreign currency, Interest arbitrage 32 - 35Foreign exchange rates, 167 IMS, 52, 53, 56 Foreign exchange transactions, amendments to, 57, 59 Industry, and Eurocurrency transactions, 142 basic principles, 2-5 buyers and sellers of, 5-8 Inflation examples, 1-2 and currency crises, 123 during Great Depression, 80 price relationship, 3-5 speculation, 109-115 rates as indicators, 150-151 Foreign exchange unification. Instruments, 163-167 See European currency cross-market arbitrage, Forward 166-167 covering of foreign currency, forward rate agreements, 166 26 - 29interest rates and currency deals, 18-19 swaps, 164-166 rates, 46-47, 182 interest rate guarantees, 166 Forward rate agreements, 166, Interest arbitrage, 6, 39-49, 167 164 Futures, 169-173 and business transactions, 47-49 covered arbitrage, 41-43 Garmen, Mark, 183 forward rates, 46-47 Gold hot money, 44-46 crises, 82 theory of, 39-41 demonetization, 83-84 Interest rate futures, 167 exchange rate and, 53 Interest rate guarantees, 166, gold pool, 81-82 history of, 79-81 Interest rate options, 167 as reserve currency, 68, Interest rates, 151-152, 164, 84-85, 90-91 182 Government paper, 167 Interest rate swaps, 167 Group of Twenty, 59 International Foreign Exchange Club, 15, 23 International Forex Club, 160 H International Monetary Fund, Hard currencies, 151 7-8, 52, 53, 56, 126 Hedge ratio, 183-184 Hot money, 6, 44-46 amendments to, 57, 59

gold sales, 84
and speculation, 115
and world liquidity, 91
International Monetary Market,
171
Intervention, by central banks,
53-56
Intrinsic value of option,
180-181
Invoiding, 31-35

Johnson Measures, 98

K Kohlhaggen, Steven, 183

Lead reserve currency, 68–69, 122
LIBOR, 166
LIFFE, 171
Liquidity, 89–95
London Inter-Bank Offered
Rate (LIBOR), 166
London International Financial
Futures Exchange, 171

M
Monetarist economic theory,
151
Money flows, 105–107
Money market and foreign
exchange market. See
Interest arbitrage

N Numeraire, 93–94

Option pricing, 180–182 Ordinary spot, 19 Over-the-counter options market, 176, 177

Petrodollars, 139, 154
Plaquet, Maurice, 15
Politics, and exchange rates, 153–154
Premium, 19–20, 177
Pricing, of financial futures, 172
Public relations, and currency crises, 126–127
Purchasing Power Parity Theory of Money, 150
Put option, 175, 182

Qualitative approach to forecasting, 146–147

R
Reserve currencies, 66–69,
84–85, 90–91
Roosevelt, President Franklin
D., 79–80

Scholes, Myron, 182 Short-term borrowing, 126

Index

Singapore International Monetary Exchange, 171 Special Drawing Rights, 60, 91-95, 125, 131 and gold, 80, 83 as numeraire, 93-94 as world currency, 94-95 Speculation, 6-7, 109-115 government interest in, 114-115 role of speculators, 112-113 Spot covering of foreign currency, 26 - 29deals, 18-19 delivery, 7 Spot market, intervention in, 55-56 Sterling area, 64-65 Strike price, 177, 181 Swaps, 21-22, 29-31, 164 Switzerland convertibility of currency, 97-98

T

Third world countries, and effectiveness of Bretton Woods, 56 Third World Debt Crisis, 99
Time option forward contracts,
29–31
Time value of option, 181
Trade-weighted index, 60
Treaty of Rome, 71, 106

U

Underlying currency, 177
United Kingdom
and EMS, 75–77
and Eurocurrencies, 136
United States
competition for Eurodollars,
137, 139
U.S. dollar
exchange rate and, 53
as reserve currency, 68

V

Value date, 18 Variable exchange rate currency swap, 165

W

Werner Plan, 72-74 World debt crisis, 130